CAPITOL HILL HAUNTS

CAPITOL HILL HAUNTS

TIM KREPP

Haunted America

Published by Haunted America
A Division of The History Press
Charleston, SC 29403
www.historypress.net

Copyright © 2012 by Tim Krepp
All rights reserved

Front cover image by Clift A. Seferlis.

First published 2012

Manufactured in the United States

ISBN 978.1.60949.586.2

Library of Congress CIP data applied for.

CONTENTS

CONTENTS

ACKNOWLEDGEMENTS

I'd like to thank my wife, Denise, for her patience and support while I was working on this, especially for keeping calm as the clutter on my desk gradually overtook the back portion of our house. We haven't seen the dog in weeks by the way. On that note, a special thanks to my daughters, Cason and Megan, whose insightful comments like, "Dad's not working. He's just playing around on the computer," served to keep me focused.

I'm particularly lucky with not only Hannah Cassilly and the team at The History Press but also their circle of local authors, with whom I'm able to bounce ideas and trade tidbits. To Robert Pohl, my partner for Hill ghost tours; Garrett Peck, who literally wrote the book on beer in Washington; and John DeFerrari, who probably *does* know where the skeletons are: I appreciate all the help.

I'd also like to thank all my neighbors and fellow residents of Capitol Hill, one of the greatest places to live in the entire country. Their collective assistance in tracking down stories and ghostly tales and providing background and just all-around support has been phenomenal. A particular thank-you goes to my friends Maria Helena Carey, for her wonderful photographs, and Geoffery Hatchard, who while not quite a Hill rez is D.C.'s reigning cartographic expert.

While Washington, D.C., is a researcher's dream with so many wonderful facilities a Metro ride away (or closer), I'm particularly indebted to some online resources, namely the District of Columbia's Public Library for accessing the *Washington Post* archives and the Library of Congress's

ACKNOWLEDGEMENTS

Chronicling America for putting centuries of newspapers a keyword search away. David, Dan, Leslie, Kate, Ed and many others, your "hard" work is appreciated. Otherwise I'd have to get dressed and leave the house.

Finally, a shout out to the morning crowd at Peregrine Coffee for being the best place in Washington, D.C. for some astonishingly productive time wasting. Too many to name them all, but a big thanks to Louis Bayard and Jennifer Howard for taking a look at this and not laughing out loud. I'm always amazed at how much gets done there, even when I don't plan on it. Also, the coffee is damn good.

INTRODUCTION

D o you believe in ghosts?"
There it is. This is the question I always get when I give a ghost tour or mention that I'm writing a book about ghosts. So, how to answer? The truth is that I neither believe nor disbelieve in ghosts. I maintain a studious neutrality on the topic. I'm here to gather the stories and retell them in as engaging a manner as I can. Some leave me skeptical, and some have my mind racing when I walk down dark allies. But one thing I can say: these stories are all real, 100 percent true ghost stories. It says so right on the label. Or at least they are "true" and "real" in that I made none of it up.

So where do I get them from? Everywhere and anywhere I can, of course. Some, such as the Demon Cat, have been told and retold for decades now, so that they have become part of our cultural zeitgeist. Some, such as the wonderful Phantom Wheelman in the second part, are culled from newspaper accounts I've stumbled across. But my favorites are those that are told to me in person. It's been a pleasure gathering these stories of unexplained phenomena and bringing the tales of Hill haunts into the twenty-first century.

Ghosts are wonderful entities to use to explore life. They represent a gateway into a foreign country: our past. Even though we walk through streets that were laid out in the 1700s and live in houses that were built in the 1800s, life in those years was remarkably different from today. The Phantom Wheelman story tells of life when bicycles were new and

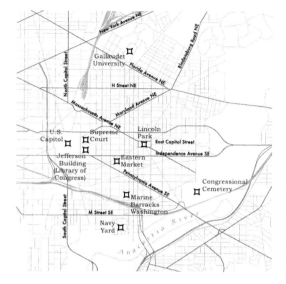

Greater Capitol Hill. While no official definitions exist, Capitol Hill, broadly defined, runs from North and South Capitol Streets on the west to the Anacostia River on the south and east and to Florida Avenue in the north. *Map by Geoffery Hatchard.*

streetcars commonplace. An 1893 article about Georgetown ghosts dismisses ghosts in the District Jail, illustrating that the pervasive racism of the time transcended to the afterworld. The Buried Treasure tale of the Marine Barracks shows that some values, like dedication to duty, are timeless. These ghosts do more to show us what life was like back in the day than any number of history textbooks can.

I should point out that there is no such thing as an official designation of what is and what is not Capitol Hill, and even what is understood to be the Hill has truly changed over the years. Today, very broadly speaking, we can say that Greater Capitol Hill stretches from the Capitol in the west to the Anacostia River in the south and east and to Florida Avenue along the northern edge.

I've kept my definitions of the Hill loose, and sharp eyes will note that some of these stories, in particular the tales of Gallaudet University, are outside the strict definition of Capitol Hill. I've done that because they're just some darned good stories and because the students, faculty and ghosts themselves have played and continue to play parts in the richness of the Capitol Hill community.

Most of all, in researching this book, I've confirmed what a fascinating neighborhood I live in. There have been so many times I've come across a wonderful story only to find that there is no ghost. I've resisted the nagging whisper in the back of my head, uttering over and over, "Just make it up,"

as best I can, but there is so much more out there to tell. I hope that this book encourages people to walk out the East Front of the Capitol and not get on the Metro. I also hope it helps my neighbors to see a side of our history not often told.

PART I

THE HAUNTED CAPITOL BUILDING

Obviously, the Capitol Building is haunted—so well haunted, in fact, that in 1898 the *Philadelphia Press* called it the most thoroughly haunted building in the world.

How could it not be? It is one of the oldest buildings in the city and has been the epicenter for drama high and low for more than two hundred years. It is the symbolic center of the District of Columbia, so much so that our lettered and numbered roads start from here. Obviously, weighty decisions of great national and international importance have been and still are debated here, but the Capitol has also seen its share of violence, heartbreak and just general mayhem as well.

The Capitol, as both a building and an institution, has grown and changed alongside the country. George Washington laid the cornerstone in 1791, and the original plans called for a structure that would have been the most impressive building in the young nation, though much more modest than the grand structure we are accustomed to today.

Those plans were drawn up by William Thorton, a prominent polymath originally from the West Indies who, as just about every history of the Capitol will explain, was not a professional architect. This was not particularly unusual in late 1700s America, as architecture was just beginning to emerge as a separate discipline from construction, a process that was even less advanced in the New World.

Rather, William Thorton is often described as a doctor, having been educated as such at the University of Edinburgh. But he never really warmed

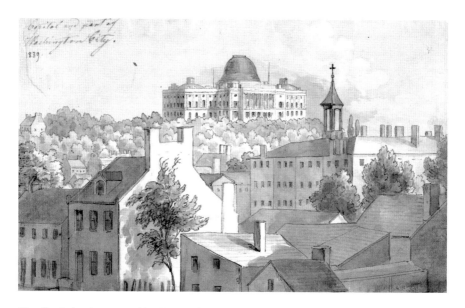

The Capitol as it appeared in 1839, before the dome was replaced with today's cast-iron version; the House and Senate wings had yet to be built. *Drawing by Augustus Köllner, Library of Congress, Prints and Photographs Division.*

to the profession of medicine, and perhaps for good reason.[1] Among his few forays in the field was a case for which he was called to the bed of a dying George Washington. Arriving the morning after the general died, he refused to give up hope, writing in his own words years later:

> *The weather was very cold, and he remained in a frozen state, for several days. I proposed to attempt his restoration, in the following manner. First to thaw him in cold water, then to lay him in blankets, and by degrees and by friction to give him warmth, and to put into activity the minute blood vessels, at the same time to open a passage to the lungs by the trachea, and to inflate them with air, to produce an artificial respiration, and to transfuse blood into him from a lamb. If these means had been resorted to and had failed all that could be done would have been done, but I was not seconded in this proposal; for it was deemed unavailing.[2]*

Martha said no.

Unfortunately for the construction of the Capitol, many of Thornton's ideas were only somewhat more practical than his practice of medicine. In 1802, Thomas Jefferson appointed him head of the Patent Office, a position far more suitable to his abilities.

Lenthall's Curse

A British professional architect, Benjamin Latrobe was brought in to tidy things up a bit and move the ambitious Capitol project forward. Among many notable changes was one moving the House and Senate Chambers to the second floor, which would allow air to circulate below them and allow a little relief in the hot and humid Washington summers.

For the Senate, that meant taking the very large Senate Chamber and cutting it in half by adding a floor below. To build the new floor, Latrobe used stone ribs supported by brick piers to build a vaulted ceiling. This was a somewhat daring and ingenious method and had the attraction of not resting on the presumably unsound earlier work.

The new space created on the ground floor would eventually become the Old Supreme Court Chamber, still open from time to time on tours of the Capitol. The court would sit here from 1810 to 1860 until it was moved to the Old Senate Chamber.

This was all very well, but the Capitol was not Latrobe's only commission, and he hired his friend John Lenthall to supervise when he was busy elsewhere. Lenthall was made Clerk of the Works, a position we might call construction manager today. The design was tricky and intricate, however, and Lenthall attempted to economize by using less material and subtly

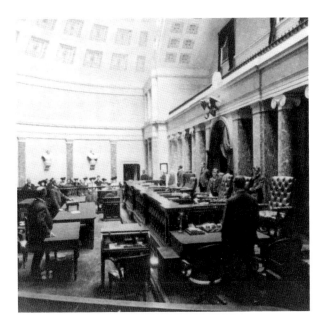

The Old Supreme Court Room in the Capitol as it appeared in 1904. The collapse of the vaulted ceiling killed the clerk of the works, John Lenthall. *Underwood and Underwood, Library of Congress, Prints and Photographs Division.*

changing the design. When it came time to remove the wooden supports, a decision Latrobe later wrote was premature, the stone and brick vaulting collapsed. Lenthall was crushed to death and, as he lay dying, uttered a curse on the building that killed him.[3]

Latrobe would be personally and professionally haunted by his friend's untimely death, but Lenthall's curse seems to have left Latrobe to his guilt and plagued the Capitol Building itself. As the Capitol has been expanded over the last two hundred years, unexplained structural failings, mysterious crumbling columns and even delays on the recently completed Capitol Visitor Center supports are chalked up to that final curse uttered by John Lenthall.

GHOSTS OF THE ROTUNDA

As the young nation matured, it became apparent that the Capitol must grow as well. The chambers of both the House and especially the Senate were proving to be too small, so new plans were drawn up by Philadelphia architect Thomas U. Walter to build two new wings, clad in marble. As the proportions of these new wings dwarfed the existing copper-clad wooden dome, a new 288-foot cast-iron dome was planned to replace it. Construction began in 1855, and in 1861, President Lincoln was sworn in before an unfinished dome. Despite the grave national crisis of the Civil War, he insisted that work continue and drew strength from the placement of the statue of Freedom atop it in 1863. The dome would not be fully completed until 1866, after his death.

Naturally, the work of building the new dome while also dismantling the old one was particularly tricky, and Thomas Walter turned to master carpenter Pringle Slight. Slight had helped build the original dome, designed by Charles Bullfinch, and had been employed as the Capitol's handyman ever since. He knew where all the skeletons were hidden, metaphorically speaking of course.

Working with Walter and Captain Montgomery Meigs of the Army Corps of Engineers, who directly supervised the project, Pringle Slight built curved ladders to remove the copper cladding in single pieces so that it could be resold. He was also aware of the former hole in the Rotunda floor that had been closed off in 1828 and designed a tripod scaffolding to work above it. To protect the Rotunda from the elements while the dome

The Haunted Capitol Building

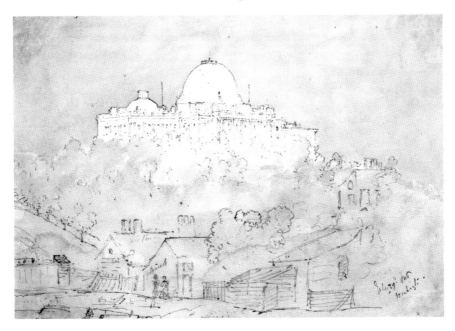

In this 1846 sketch from the railway station near the Mall, the copper-clad wooden dome is clearly visible. New House and Senate wings would make it disproportionate and necessitate a new dome. *Michael Seymour, 1846, Library of Congress, Prints and Photographs Division.*

was replaced, he constructed a wooden roof. His assistance was invaluable in completing the project.

Sadly, and ironically, Pringle's son, Robert Slight, fell onto that wooden roof while also working on the dome. He survived several days but finally succumbed to his injuries on December 27, 1861. But Robert didn't let his untimely death deter him from completing work on the new dome. He can still be seen walking through the Rotunda, clad in work clothes and carrying his tools, on the way to climb the scaffolding for his final day of work.[1]

Nor is Robert Slight the only ghost in the Rotunda. Starting with Senator Henry Clay, the Rotunda has been considered the most suitable place for national figures to lie in state. Twenty-nine Americans have been granted the honor, most recently President Ford in 2007. All but Clay (obviously) have rested on the Lincoln Catafalque, a platform hastily constructed of rough pine boards after his death and now on display at the Capitol Visitor Center.

Among those who have lain in state is the unknown soldier from World War I. Following the war, there was a desire to recognize those who could not be identified. Great Britain and France started the trend by interring a single

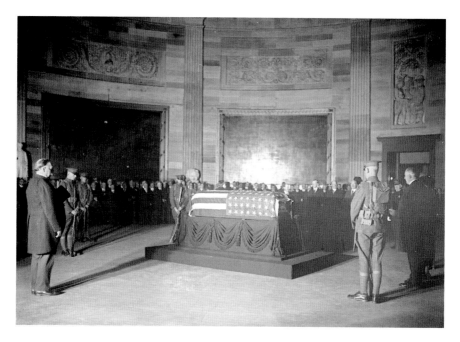

The unknown soldier from World War I lay in the Rotunda for three days in November 1921. Here, President Harding and Vice President Taft pay their final respects, 1921. *National Photo Company, Library of Congress, Prints and Photographs Division.*

soldier in Westminster Abbey and the Arc de Triomphe, respectively. The United States followed a year later, and an unknown soldier was brought to the Washington Navy Yard by the USS *Olympia*. From there he was brought to the Capitol, where he became the eleventh person to lay in state in the Rotunda. For three days he laid there, and then he was taken to Arlington National Cemetery, where he is today guarded around the clock by soldiers from the Third Infantry Regiment.

But perhaps the unknown soldier has one final duty to preform. Legend has it that when the other unknown soldiers—from World War II and the conflicts in Korea and Vietnam—have come to lay here, the soldier, attired in his doughboy World War I uniform, appears briefly, snaps a sharp salute and disappears into thin air.[5]

THE DEMON CAT

Without doubt, the best-known ghost of the Capitol is the famous Demon Cat, or "D.C.," as it is occasionally known. The story varies with each telling, but in general, the cat is seen at night in the lower reaches of the Capitol, often in the crypt that was built for George Washington but never used. When first seen by the flickering glow of a lantern, it appears to be a normal tabby cat, unusual perhaps but no real source of concern. After all, mice and rats were (and often still are) constant problems in the Capitol, and cats were kept on staff as mousers.

But then it fixes its spectral eyes on its hapless victim, with a glow described as "having all the hue and ferocity of a fire engine entering one of Washington's notoriously dark alleys."[6] As the witness stands rooted at the site, either in fear or some sort of supernatural hold, the cat approaches, growing in size. The terrified observer swears that it reaches the size of an elephant or, at the very least, a good-sized tiger. Finally, "this demon cat emits a fierce yowl and with eyes ablaze and mouth open leaps toward the spectator, but invariably leaps quite over his head."[7] He disappears into the darkness, not to be seen again soon, although it's unlikely that the watchman put up much of a search.[8]

As many of the nocturnal observers were watchmen or Capitol police officers, it was not uncommon for the officer to take a shot at it. In an 1862 episode, the watchman shot at it, but nothing was hit and no corpse of a giant cat was found. A description in the early 1930s of a more recent shooting indicated that "the Stygian feline appeared to have the eyes of Eddie Cantor and the generous proportions of Mae West plus the disposition of Bela Lugosi." If this riot of a metaphor needs decoding for modern readers, Eddie Cantor was a vaudeville performer known as "Banjo Eyes," Mae West was an actress so well endowed that a rather bulky life jacket was named for her and Bela Lugosi is known for his title role in the 1931 movie *Dracula*.

Over time, the legend grew that the feared Demon Cat was a harbinger of doom, appearing before national calamities. It was claimed, often years after the fact, that D.C. appeared before Lincoln's assassination, the stock market crash of 1929 and Kennedy's assassination. Noticeably missing from this list is Pearl Harbor and 9/11, but perhaps we shouldn't look a gift cat too closely in the mouth.

But not everyone was a believer. A 1909 article recalls an amusing anecdote from a few years earlier:

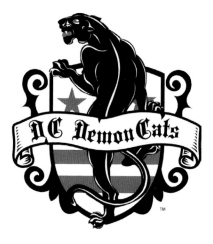

The DemonCats of Washington, D.C.'s flat-track roller derby league got their name from the Capitol's most famous ghost. *Courtesy of DC Rollergirls.*

When the body of President Garfield lay in state at the capitol an old engineer who was employed in the basement and who ridiculed the idea of ghosts decided to be avenged upon the watchmen and policemen who remained in the building through the night. He procured two large English walnuts, securely tied the half shells on the four feet of the pet cat and carefully turned her loose in Statuary Hall.

The noise of these shells on the marble floors at midnight in the near darkness as the distracted cat scampered about, trying to get rid of her new shoes, gave the watchers the worst fright of their lives.[9]

Well, it was amusing to everybody but the cat.

While the Demon Cat apparition hasn't appeared in some time at the Capitol, the D.C. DemonCats live on as a team name for Washington's own roller derby league, the D.C. Rollergirls. According to team co-captain "Hooah! Girl," the team started out as the National Maulers, but it conflicted at the time with a similar name elsewhere. Fortunately, team member "Blonde Fury" knew the story of the Demon Cat, and they "knew right then that we wanted that name for the team."

JOHN QUINCY ADAMS'S LAST ADDRESS

One of the most dramatic events in the history of the Capitol occurred in the old House of Representatives Chamber, now Statuary Hall, on February 21, 1848. The House, and indeed the nation, was celebrating the end of the Mexican-American War, an event that had sparked a surge of patriotism. Accordingly, now that American forces were victorious, the House was voting to honor the U.S. Army for its service by awarding medals to senior officers.

This was understandably a popular decision, and only a small majority opposed it. A proposal to close debate was offered, and one voice loudly "voted 'No,' with unusual emphasis; the great loud No of a man going home to God full of 'the unalienable right of resistance to oppression,' its emphatic word on his dying lips."[10]

That voice belonged to John Quincy Adams, the only president to continue his public life by serving as a representative after his term of office. Adams had been soundly defeated by Andrew Jackson in the 1828 presidential election, but he found new strength in the House. Freed of his responsibility to the nation as a whole, he championed issues dear to his heart, notably the founding of the Smithsonian Institution and fighting slavery. Adams would be an increasingly loud and persistent voice against human bondage in a way that he hadn't necessarily been as president.

It was this issue that drove his strident opposition to the Mexican-American War and, by extension, to closing off debate on the proposal to award medals to army officers on that eventful day. As Adams rose to emphatically object, he suffered a massive cerebral hemorrhage and was taken to the Speaker's Room just off the chamber. He died there two days later, wife and son by his side. "This is the last of the earth. I am content," were his final words.

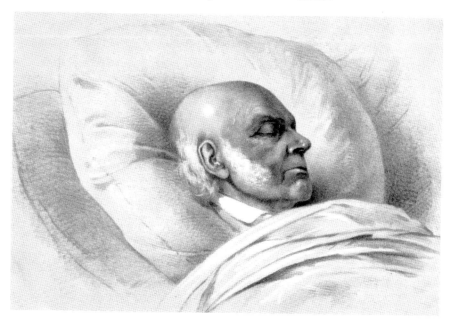

John Quincy Adams sketched a few hours before his death in 1848, at rest on a couch in the Speaker's office. *Arthur J. Stansbury, Esq., lithograph by Sarony & Major, Library of Congress, Prints and Photographs Division.*

But he must not have been that content, for he never left. Adams was nothing if not a passionate advocate against slavery, and he had for years challenged the House's "Gag Rule" that prohibited discussion of the topic. If proslavery southern politicians couldn't stop him from loudly decrying it, certainly death couldn't. To this day, Adams rises to speak, finishing the speech the stroke curtailed.

"Old Man Eloquent," as he was both respectfully and derisively called, was first seen a few years after, on the cusp of the Civil War, when the House was moved to its current home in the new House of Representatives Chamber. He has since been seen repeatedly over the years and is a regular fixture in contemporary newspaper stories about ghosts of the Capitol.

In one particular example, the witness was a member of the Capitol Police. Today a professional and well-trained police department, at one point the Capitol police was often regarded as a source of patronage jobs for congressmen, which perhaps explains why our officer was being dismissed for drunkenness. Either way, he testified in his sworn statement that he saw not only John Quincy Adams but also the entire Congress of 1848 going about their business in Statuary Hall.[11]

At Statuary Hall, Capitol Historical Society chief guide Steve Livengood often sees John Quincy Adams rise to give his final address. *Bain News Service Collection, Library of Congress, Prints and Photographs Division.*

A more credible eyewitness is the U.S. Capitol Historical Society's chief guide, Steve Livengood. Mr. Livengood often attends functions on the House side of the Capitol, and as he returns to his office late in the evening to retrieve his coat, he passes through Statuary Hall. As he put it, "If I've had a lot of wine, I always see John Quincy Adams's ghost in Statuary Hall, giving the speech that he wanted to give attacking the presentation of medals to the generals in the Mexican War because he felt it was an unjust and imperialistic war."[12]

The Speaker's Room where Adams passed away became in time the Congressional Ladies' Retiring Room, addressing an issue that earlier Architects of the Capitol had not foreseen. It was later formally renamed the Lindy Claiborne Boggs Room, the first, and to this day only, time a room has been named for a woman in the Capitol. When she dedicated it in 1991, former congresswoman Boggs quipped, "When they finally gave us a room, wouldn't you know that they'd give us one that was haunted?"

WILBUR MILLS'S OFFICE HOURS

John Quincy Adams is a relatively common apparition on the House side of the Capitol, but Steve Livengood has also come across a more personal ghost, to his knowledge the one only he has seen. As he relates it:

> When I first started working in the Capitol, Wilbur Mills was the chairman of the House Ways and Means Committee. He really was a very powerful member of Congress, and his end was unfortunate. But back in that era, members had a lot more time. And he kind of kept office hours as many members did.
>
> Well, Wilbur Mills held his office hours right outside the Ways and Means Committee Room, right off the House Chamber, on that transverse corridor. So any member who wanted to talk to him about something could find him there. And so it was very common for me to walk by there when I was in college and see Wilbur Mills there. And I really can't walk past that corner without seeing Wilbur Mills standing there.

Wilbur Mills is best remembered by the scandalous end of his career, when his car was stopped near the Tidal Basin by the Park Police. His

House Ways and Means Committee. *Photo by author.*

passenger, an Argentinian stripper named Fannie Foxe, jumped out and attempted to get away by swimming through the Tidal Basin.

Obviously something like that is bound to leave an impression on the public, but Wilbur Mills was also the very respected, longest-serving chairman of the incredibly powerful Ways and Means Committee. His adroit and inclusive leadership caused him to be known, unofficially of course, as the "Most Powerful Man in Washington" and put his face on the cover of *Time* magazine in 1963.

Steve remembers Mills as the "one chairman who never lost a vote" and attributes that to his availability to other members, which allowed him to have his votes lined up before taking anything to the floor. He was interested in what other members wanted and was straight with them, a valuable and sometimes rare commodity on the Hill. This made a strong personal impression on Steve, which is perhaps why he sees Wilbur Mills consistently while others walk by an empty corridor.

TUBBING WITH HENRY WILSON

While John Quincy Adams and Wilbur Mills keep the House side on its toes, the Senate is well haunted as well.

The Senate is an odd organization, as it is purposefully kept at even numbers, which could always leave open the chance of a tie. To deal with this, as every school kid knows, the vice president is also the president of the Senate, casting the tie-breaking vote when necessary. Well, maybe not every school kid, but certainly the ones who listen to their tour guides.

This has always been a somewhat awkward position for the vice president. Between casting this vote and potentially succeeding the president, they have no other constitutional duties. Any influence they have is a result of their personality and ability to navigate the currents of Washington politics. John Adams commented on the position that "[m]y country has in its wisdom contrived for me the most insignificant office that ever the invention of man contrived or his imagination conceived."[13] John Nance Gardner, FDR's vice president, said that the job was "not worth a bucket of warm spit," although he may very well have not used the word "spit."[14]

But not all vice presidents have struggled so with the role. Henry Wilson, President Grant's vice president, eased into the job quite nicely. Too nicely perhaps. Vice President Wilson was a schoolteacher and cobbler from Massachusetts when he became involved in politics. After a stretch as a state legislator, some unsuccessful runs for the House and being governor of Massachusetts, Wilson was selected by the state legislature to be a senator (no direct vote in those days) in 1855. He was part of the faction known as "Radical Republicans" and was ardently against slavery and for a strict Reconstruction after the Civil War. He also gained a bit of notoriety for spending an inordinate amount of time with Rose Greenhow, the Confederate spy, at the outbreak of the Civil War and for possibly spilling the beans about the Union's plans for the First Battle of Bull Run.

But whatever happened, Henry Wilson was selected for the fate that often befalls well-meaning Senators: running for vice president. He and General Grant ran under the campaign slogan of the "Workingman's Banner," with Grant cast as the "Galena Tanner" and Wilson as the "Natick Shoemaker." It's an open question as to exactly how many years it had been since either of them had tanned a hide or made a shoe.

Either way, Henry Wilson (and Grant, of course) ended up winning the 1872 election, and Wilson found himself with quite a bit of time on his hands. He began the third and final volume of his exhaustive series, *The History of the Rise and Fall of the Slave Power in America*, but otherwise he enjoyed the collegial atmosphere of the Senate. As a former senator himself, he was quite welcome and comfortable in the halls of power, and he made more use than many vice presidents of his official office in the Capitol. In particular, he enjoyed the use of the Senate bathroom, a relic of the day when many senators had less than stellar accommodations in their temporary quarters in the boardinghouses and taverns of a young Washington. The baths were a social place, with senators relaxing in the steam out of the reach of lobbyists and reporters.

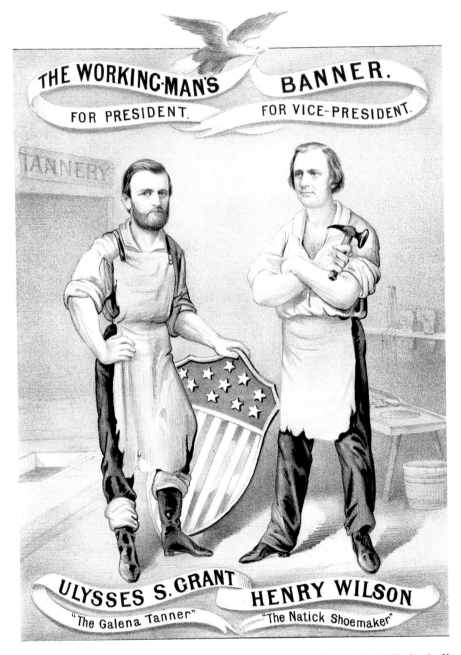

Grant and Henry Wilson campaigned under the "Workingman's Banner" in 1972. *Currier & Ives lithograph, Library of Congress, Prints and Photographs Division.*

Wilson's health was fading, however, and talk of a potential presidential run at the end of Grant's term dried up. Wilson suffered a minor stroke on November 10, 1875, and although still mobile, he elected to remain at the Capitol. A bed was prepared for him, and Capitol police officer. F.A. Wood was assigned to assist him. Despite Officer Wood's patient nursing, his health continued to decline. He would seek relief in the tubs, and the *New York Times* reported toward the end that "he was prostrated in the bath-room of the Senate, although he had been suffering for several days." He died the next morning, at 7:20 am, on November 22, 1875, in the official office of the vice president in the Capitol.[15]

Not long after, rumors began to fly of an apparition of Henry Wilson returning to his office from another session of "tubbing." On one occasion, he startled a Capitol police officer who was standing watch over a Tennessee senator, presumably Isham G. Harris, who died in 1897 and who was laying in state in the Senate Chamber. The watchman was understandably startled and nearly frightened to death, but Wilson's actions were "doubtless uncontemplated, inasmuch as the Senator was too well bred a man to take anybody by surprise."[16]

Not all of Vice President Wilson's appearances are visual, however. Periodically, people walking outside the door to the Office of the Vice President will hear a mysterious coughing when no one is there. Others have reported a damp chill in the air or the smell of old soap. It's all just the ghost of Henry Wilson, enjoying a final bath.[17]

THE HAUNTED COMMITTEE ROOM

Yet another senatorial ghost that haunts the Capitol is Senator John A. Logan. Logan spent most of his adult life switching back and forth between the military and politics. Despite having no formal education of any sort until he turned fourteen, he managed to attend college before being commissioned a second lieutenant in the army for the Mexican-American War. Following the war, he became a lawyer and worked his way up the political food chain.

The outbreak of the Civil War found him in Washington as a two-term Democratic representative. He resigned his seat and rejoined the army, a not uncommon choice for many congressmen. In heavy fighting, he managed to get a horse shot out from underneath him in one battle and was wounded in

another. He was soon promoted to general, and he briefly commanded the Army of the Tennessee during the Battle of Atlanta.

After the war, General Logan returned to the House, this time as a Republican, and then made the leap over to the Senate. He was also quite active in veteran affairs, serving as commander in chief of the Grand Army of the Republic, an organization for Union veterans. As such, he spearheaded the establishment of Decoration Day (now Memorial Day), choosing May 30, a date specifically chosen for not having had any major battles on it.

In the Senate, Logan served as chairman of military affairs, a position he was quite well suited for. But perhaps he didn't entirely trust his successors. From time to time after his death, he was seen to step into the committee room or its adjoining corridor, dressed in a black slouch hat. He says nothing, just seemingly keenly aware, and observes the doings of the committee.[18]

Another story advises seekers of John Logan to wait outside the committee room "at exactly a half an hour after midnight on the first Tuesday in the dark of the moon." And then, at the stroke of this particular half hour, no more, no less,

the door slowly opens and there, standing in a "blue haze of light," as one eyewitness describes it, is the figure of Gen. Logan, deceased for nearly half a century. For exactly 15 seconds he stands there motionless and undecided, as if waiting for a Mount Pleasant car during the noon rush hours, at the termination of which period the huge doors close just as softly, leaving the spectators free to move on to the specters—or take an aspirin![19]

THE BLOODY STEPS

Not just congressmen work at the Capitol, so its natural that not just congressmen should haunt it. Since the beginning of the republic, people have wanted to get information to their congressmen and people have wanted to get information from them. As such, lobbyists and reporters have wandered these halls since they were built and are no doubt doing it as you read this. Both professions can suffer from a poor public image and they can certainly be relied on as foils when politicians need to blame someone, but both fill a needed role in our system of government. When the cameras are off, it's not surprising to see a congressman, a journalist and a lobbyist having a drink together.

This is not to say that all three coexist harmoniously at all times—or even peacefully. A particularly violent falling out occurred in the wake of the 1886 election. Democrat William Preston Taulbee was reelected by a narrow margin in the Kentucky Tenth District and was settling in for what appeared to be a tough new term when a story by the Washington correspondent of his hometown *Louisville Times*, Charles Kinkaid, broke with the headline "Kentucky's Silver-Tongued Taulbee Caught in Flagrante or Thereabouts." Kinkaid kept the story alive, and not only did Taulbee choose not to run in the next election, his chosen successor lost as well.

Taulbee did what so many ex-congressmen do and took up lobbying. As such, he came in constant contact with Kinkaid, who was still on the Capitol beat. Taulbee, broad shouldered and a foot taller than Kinkaid, delighted in taunting the scrawny journalist. In February 1890, the two met on the steps outside the House Gallery. Accounts vary as to exactly what words were used, but there's general agreement that Taulbee taunted Kinkaid again, possibly tweaked his nose and suggested they step outside. Kinkaid responded that he was "in no condition for a physical contest with you—I am not armed," to which Taulbee responded, "Then you had better be," or

The blood of William Taulbee is permanently stained into the marble steps coming down from the House Gallery. *Photo by author.*

perhaps, more lyrically, "You damned little coward and monkey, now go and arm yourself."[20]

Either way, Kinkaid left and returned a few hours later. As Taulbee was descending the stairs, Kinkaid called out, "Can you see me know?" As Taulbee turned, Kinkaid shot him in the face. Taulbee initially survived the shooting but died of the wound several days later. Kinkaid was acquitted on the basis of self-defense, and the story faded from memory except for one nagging detail.

To this day, if you walk down the steps on the east side of the Capitol, descending from the House Gallery, you will come across the bloodstains of William Taulbee, permanently staining the marble. No amount of scrubbing has managed to erase them. And if you happen to be a journalist, take particular care. The ghost of William Taulbee likes to trip reporters on this particular flight of stairs.

KEEPING THE CAPITOL RUNNING

There has been an unwritten side to Capitol history, at least until recently. The experience of African Americans has often been overlooked, especially considering that their labor helped build the place. In the last few years, this narrative has changed, and the slaves who helped build the Capitol, the Reconstruction-era African American congressmen and leaders of the civil rights movement, black and white, have begun to take their rightful places in history. The welcome hall of the new Capitol Visitor Center has been christened Emancipation Hall, and few tour guides will take you through the Capitol without some recognition that American history does include people of color.

It's not as if African Americans weren't at the Capitol. They have been since the beginning—first as slaves and then often in jobs that gradually carried a great deal of prestige within the African American community. While not holding the levers of power, they were cutting the hair, driving the cars and cleaning the floors of those who did, visible and yet unseen. So we can deduce two things: there are African American ghosts in the Capitol, and the historical record of them is spotty. But two deserve mention here.

The first comes from a 1919 article and refers to a "well-authenticated ghost," an "old white-haired negro named Osborne." Osborne's job was to scrub the floors of the Senate corridors, a job he did diligently night after

night while the rest of the world slept. Osborne passed away one day but continued on in his assigned task even in death. "He haunts the basement," the account goes, "where the sound of his brush and pail, with a slosh of spectral water, is heard from dark corners, his phantom still pursuing his old-time occupation." Osborne's ghost was so well established that his fellow African American workers refused to begin working in the Senate basement until daybreak, starting their rounds in the aboveground chambers first.[21]

While Osborne was one of the legions of African Americans employed in cleaning and other menial jobs, the second tale involves a gentleman with a somewhat more refined position: a barber. It may sound somewhat mundane to modern ears, but in the 1920s, a barber may have been the highest-paid and most esteemed black professional an upper-class white man might encounter in his daily life. In the ethnic stereotypes popular in the day, African American barbers were considered far and away the most skilled, and the Senate was no exception. No self-respecting senator would deign to get his hair cut by a white man. And John Simms was the dean of the Senate barbers.

Referred to universally as Bishop Simms from his sideline as a preacher at Holiness Church, Simms had been "saving and shaving" in the U.S. Senate for forty years by the time the *Afro-American* ran a profile of him in 1928. It's not that Bishop Simms hadn't had better offers. Calvin Coolidge had been impressed with him when he had been vice president and wished to bring him to the White House when he succeeded President Harding, but to no avail. In another instance, the people of Haiti, under United States occupation at the time, had thrown their white pastor out and were clamoring for someone more sympathetic. Senator King of Utah thought that Bishop Simms would be a perfect fit, but Simms declined.

Simms preferred his current position and had a unique touch with senators. When challenged, he responded to the great and the grand with a simple "I'm eighty-five years old now and haven't time for any of your foolishness." He maintained a strict, bipartisan zone of privacy in his barbershop, rebuffing intruders courteously but firmly. And he handled with great discretion the touchy situation of senators who might have been getting a little, well, thin on top. Although he kept virtually every brand of hair tonic available, sometimes "[it] just can't be done, and a senator worried about his hair is a senator to be dealt with gently, but firmly."[22]

In 1934, Bishop Simms passed away, but his presence remained. Simms was known to break out into song from time to time. Both he and the senators found it soothing, and his death did nothing to stop

that. Periodically, "Negro spirituals in the late lamented 'Bishop Simms'' voice, still heard in the Senate barber shop," waft through the halls.[23]

Thousands of people work in the Capitol, but very few see ghosts. Perhaps it's because talking about ghosts might give voters back home the wrong impression. But Steve Livengood of the Capitol Historical Society has a better explanation: "I really get into the history, I'm very conscious of who's been there before as I walk through the building. Everyone is so interested in making history, they don't walk through it with quite the same eyes."

Keep that in mind the next time you walk through the Capitol.

PART II

OTHER FEDERAL HAUNTS

F ew visitors to the Capitol realize that relatively little of its work happens in the big white building on the hill. Final votes are held here and a few committee and senior leadership offices are there, but the actual work of Congress happens elsewhere. Four House Office Buildings and three Senate Office Buildings house the offices of 435 representatives and 100 senators, along with more than 10,000 staffers. It's a monumental enterprise, and the Capitol Building is but the tip of the iceberg.

The entire thing is administered by the Architect of the Capitol, who also handles the three Library of Congress buildings, the Botanic Garden, a spiffy new Capitol Visitor Center and even the Supreme Court building, despite being an entirely different branch of government. The complex has its own police department, the U.S. Capitol Police, which at about 1,800 officers puts it among the top twenty-five police departments in the country by size. The buildings are knit together by tunnels and even two internal subway lines, which make it possible to get from one end of the Capitol grounds to the other without seeing the sun, if that's your thing. Steam for heating and cooling water is provided by the buildings' own power plant, a few blocks to the south. Over time, it has included public parks, parking lots and, once, where the Russell Senate Office Building stands today, a six-thousand-seat baseball stadium. Naturally, this complex can be expected to contain a ghost or two.

THE PHANTOM WHEELMAN

Today, visitors to the Capitol grounds are taken in by the well-maintained and charming landscaping, but that wouldn't have been the case in 1865. It was the end of the Civil War, and although paint was barely dry on the Capitol's magnificent new dome, the grounds were a public disgrace. Every tree had been cut for firewood, the grass lawns were a muddy mess and, much like the city around it, the grounds showed the wear and tear of having been an armed camp for four years.

After some prodding, Congress decided to spruce up the place and hired renowned landscape architect Frederick Law Olmsted to plan and supervise improvements. Among the many challenges Olmsted faced was incorporating D.C.'s streetcar system into the new design.

Washington, D.C.'s very first streetcar line skirted the Capitol when it opened in 1862, running from Georgetown down Pennsylvania Avenue and then down 8th Street SE to the Navy Yard. It had been built quickly during the war to help accommodate the rapid growth of the city and had simply been laid in the most direct route right by the Capitol. Olmsted moved it farther out, along Independence Avenue, to allow room for his signature curved pathways.

This is where our story begins, on a cable car of the Capitol Traction Company, coming down Capitol Hill and heading toward Georgetown on a summer night in 1896.

It was late, after midnight, and the car picked up speed coming down the hill. Olmsted's vision was coming to fruition, but in doing so, the thick shrubbery was creating blind turns for drivers. As the car whipped around the corner and turned onto First Street, roughly where Garfield Circle is today, the gripman stationed in the front of the vehicle released the traction cable that pulled the car, slammed on the brakes and brought the car to a stop in the dark, gloomy roadway—so quickly and suddenly that the conductor in the rear of the car didn't have time to apply his rear brakes.

"Quick, John, I've run over a bicyclist for sure this time!" he shouted to the conductor. "Hurry up and we can get him out. He just went down under the fender!"

The two trainmen hurried over to the front of the car and searched through the tangle of ropes and cables that drew the vehicle. Even with a lamp, they were unable to find any evidence of a bicycle, and there was no more reason to hold up the car. The gripman, rather shamefacedly but yet obviously still shaken, returned to his post and grasped the grip that

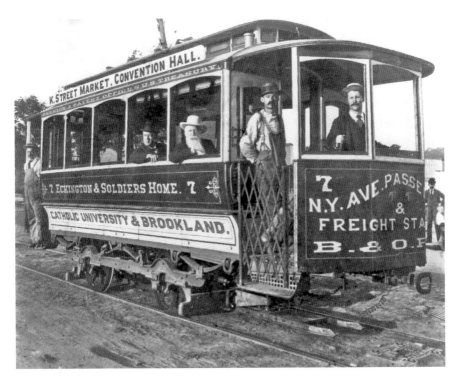

This 1890s photo illustrates the two operators required for D.C. streetcars: the gripman, who engaged the cable or electric wire and brakes, and the conductor, who took fares. *National Photo Company, Library of Congress, Prints and Photographs Division.*

connected the car to the underground cable (hence his job title), and the car continued on its way.

The story would have no doubt ended there, unrecorded to history, if a *Washington Post* reporter hadn't been on the car that evening. History, by the way, does not record exactly what a *Post* reporter was doing on a Friday night after midnight on Capitol Hill. Late-breaking story, no doubt. But whatever his state, he realized a good story when he saw one. The gripman, a grizzled veteran of the old horse-drawn (or "bob-tail") cars, was a bit reluctant to talk at first, embarrassed at his outcry and fearful of ridicule. The reporter persisted, and the gripman grudgingly launched into it. He had started work on the same line, then part of the Washington and Georgetown Railroad, back in 1875, which put him right in the middle of the cycling craze.

Today, we often forget that there was a time when the bicycle was new—and not just new but the height of excitement in an industrial age. Machinery was creeping into everyday life, but this was different. It wasn't

a hulking locomotive or a dangerous steam engine. It was personal; you could choose where to go, no longer constrained by train rails or the hassle of maintaining a horse. If you had the means to afford one and, perhaps more important, were secure enough in the middle class to have leisure time, taking a ride was all the rage, especially if you could find a hill to chase your desire for speed. Speed, as an experience, was in itself a fairly new concept, and the bicycle made it accessible.

Bicyclists sought out hills to speed down, comparing notes with one another in their desire to feel the wind in their faces. Capitol Hill was no exception, and of the several descents, the southwest side (intersecting First Street SW) was particularly prized. As our gripman put it, this "was largely patronized by cyclists who exhibited the prevailing spirit of recklessness which characterizes most riders of the present day."

The two modes of transportation came to a deadly head on a late summer night in 1882. The car was coming down the hill and making the turn onto First Street when "one of these cyclists came coasting down that hill at full speed, and crashed into my car just between the horses and the dashboard. The rider had evidently lost control of his wheel, and the instant I saw him, just a second before he struck, I observed that he was coasting with both legs hanging over the handle bar." The gripman jumped to his rescue, but it was too late. The rider was thrown under the car, and it ran over him just below the thigh. He died shortly afterward in the hospital.

Of course, the story didn't end there. The gripman continued working on the line, putting the incident behind him. But about a year after they upgraded from bob-tails to cable cars, he began noticing cyclists darting out at him from behind the very same row of hedges as had the last poor unfortunate. Each time, it was late at night, near midnight. Each time, the cyclist was real, not some phantom vision or apparition. And each time, the gripman quickly brought the car to a halt, convinced that he had run over another poor unfortunate. And of course, no sign of any cyclist could be found.

Interestingly enough, the cyclists had also upgraded. No longer were they riding the "penny-farthings" of early bicycling years, with a giant fifty-six-inch wheel, retroactively called "ordinaries." In keeping with the times, our poor gripman's "phantom wheelman" had upgraded to modern "safeties," with evenly sized wheels and chain drives. Because even ghosts don't want to be caught out in a fad.[24]

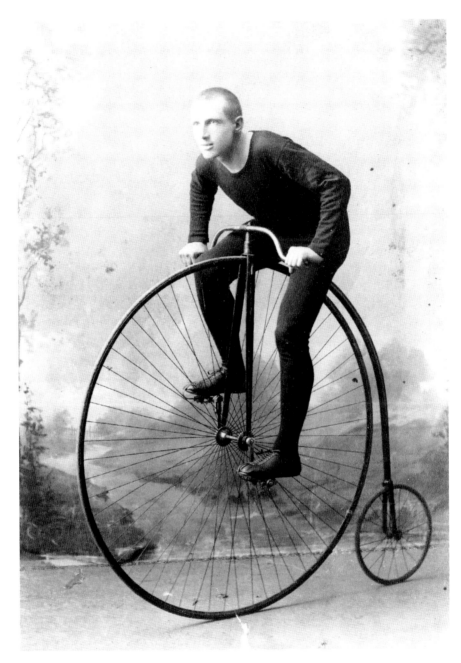

These bicycles were often called "penny-farthings" for the compared relative sizes of the two coins. They would retroactively be known as "ordinaries" to distinguish them from the newer "safeties," with evenly sized wheels. *Library of Congress, Prints and Photographs Division.*

JOHN CALHOUN'S IGNORED VISION

Today, the Capitol is buffered from the city of Washington not only by manicured lawns but also by the great marble House and Senate Office Buildings, the Supreme Court, the Library of Congress and acres of surface parking lots. At one point, these were all private buildings. Some were fine city mansions. Some were boardinghouses that catered to congressmen far from home. Some were restaurants and taverns that formed a "Ptomaine Row" along Pennsylvania Avenue, which offered a one-stop lunch and digestive illness experience. But one filled a very different role.

Following the British burning of the Capitol in 1814, a brick building was hastily thrown up in only six months across from 1st Street NE to house Congress. Once the Capitol was inhabitable again, the Old Brick Capitol, as it became known, was turned into apartments, largely for congressmen. Among its many residents were Senator John C. Calhoun, the fiery South Carolinian and champion of states' rights who died in his room here on March 31, 1850.

A few months before his death, according to an 1889 account, Calhoun related an odd occurrence that had happened in his bedchambers. At breakfast the next morning, he was noticed staring intently at his right hand and rubbing it nervously with his left. One of his companions, Representative Toombs of Georgia, inquired if his hand was in pain. Calhoun responded that thanks to a dream he had the night before, he had a perpetual black spot on his hand that only he could see. Toombs and the others were intrigued and pushed for more details. Somewhat reluctantly, Calhoun launched into his tale.

Late the previous evening, Calhoun was, quite naturally, surprised when a visitor entered his room and seated himself across the table on which he had been writing. He was all the more startled as he had given orders not to be disturbed. The room was dark, lit only by a shaded table lamp, and the stranger had a cloak about him, obscuring his face.

"What are you writing, senator from South Carolina?" the visitor asked. Calhoun, too startled to take note of the visitor's impertinence, answered, "I am writing a plan for the dissolution of the American Union."

Coolly, and with great self-assurance, the stranger asked to look at Calhoun's right hand, and then

> [h]e rose, the cloak fell, and I beheld his face. Gentlemen, the sight of that face struck me like a thunder-clap. It was the face of a dead man,

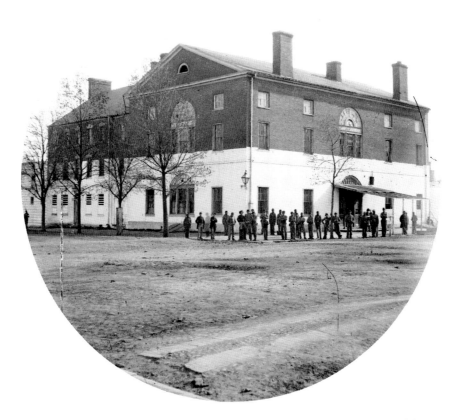

Stereographs were popular in the nineteenth century. When viewed through a special device, the two offset pictures gave an impression of depth. The Old Brick Capitol was such a landmark that visitors to the Capitol purchased stereographs to show people at home. *Stereograph, Library of Congress, Prints and Photographs Division.*

whom extraordinary events had called back to life. The features were those of Gen. George Washington. He was dressed in the Revolutionary Costume, such as those you see in the Patent Office [the Patent Office once held the Declaration of Independence and other Revolutionary War artifacts].

The intruder, as I have said, rose and asked to look at my right hand. As though I had not the power to refuse, I extended it. The truth is, I felt a strange thrill pervade me at his touch; he grasped it, and held it near the light, thus affording full time to examine every feature. It was the

face of Washington. After holding my hand for a moment, he looked at me steadily, and said in a quiet way: "And with this right hand, senator from South Carolina, you would sign your name to a paper declaring the Union dissolved?"

"Yes," I said, "if a certain contingency arises, I will sign my name to the Declaration of Dissolution." At that moment a black blotch appeared on the back of my hand.

"That," said he, dropping my hand, "is the mark by which Benedict Arnold is known in the next world."

The general then rose and pulled from under his cloak a most singular object: the actual skeleton of Isaac Hayne (presumably it was a very large cloak). Colonel Hayne was one of the highest-ranking officers hanged by the British during the Revolution. The general's parting words reflected this: "When you put your name to a Declaration of Dissolution, why, you may as well have the bones of Isaac Hayne before you—he was a South Carolinian, and so are you. But there was no blotch on his right hand."[25]

Unfortunately for the nation, Calhoun must not have heeded the ghostly apportion, black spot or no. He would rise from what would soon be his deathbed to speak against succession, kind of, in the Senate on March 4. Dying already, he was forced to allow Senator Mason of Virginia deliver it. In his address, he did briefly recall how he had "endeavored to call the attention of both the two great parties which divided the country to adopt some measure to prevent so great a disaster," but the lengthy remainder of the speech was an impassioned defense of the South and a call on the North to compromise, while offering none of his own. So whatever George Washington had told him, it didn't sink in.

THE GUILTY HENRY WIRZ

It's oddly fitting that the war that Calhoun helped bring about sparked a new, and altogether less pleasant, use for his old home. The Federal government found itself in a precarious position at the outbreak of the Civil War in secessionist-leaning Washington, D.C. Not only could the citizenry not be expected to help in the defense of Washington, but a sizable portion of it was also actively assisting the Confederacy, not least by spying for it. In order to tamp down any threat of rebellion, the Union

rounded up Southern sympathizers and found that it needed somewhere to keep them.

The Union government purchased the building and turned it into a prison. James G. Barret, the mayor of Washington, was imprisoned here for refusing to sign a loyalty oath. Rose Greenhow and Belle Boyd, two of the more famous inhabitants, were held for spying for the South. And after the war, several well-known players in the Lincoln assassination—including the physician who set Booth's leg, Dr. Samuel Mudd; the tragic Mary Surratt; and the owner of Ford's Theater, John T. Ford—were held here briefly. That is, until they were released or sentenced.

Perhaps the most dramatic moment in the Old Capitol Prison was the trial and execution of Henry Wirz. Heinrich Hartmann Wirz was a Swiss-born Confederate officer who commanded the notorious Camp Sumter prison camp near Andersonville, Georgia. Of the forty-five thousand Union soldiers who were held there, nearly thirteen thousand died of starvation, exposure, disease and murder.

At the end of the war, Wirz was captured and brought to Washington. The public was outraged at the descriptions of conditions, in particular the pictures of horribly emaciated prisoners from the camp. Unfortunately for Wirz, Lincoln's assassination had put the Federal government in a considerably unforgiving mood. However, there was little appetite for reopening wounds by holding Jefferson Davis and the Confederate command structure accountable for what clearly would be considered war crimes today. Wirz was certainly an incompetent and uncaring commander of the camp, but in many ways, he was simply the wrong man in the wrong place.

Wirz was in an impossible position. By pretty much any definition, the events at Andersonville were some of the greatest humanitarian horrors of the war, and Wirz was in command. He had taken some steps, however tentative, to address the disease and starvation, and he was acting under the direction of his chain of command. He pleaded not guilty, and his attorneys argued that he was simply following orders, that his superiors were responsible for the overcrowding as they continued to send prisoners to the camp and that it was partially the Union's fault for not allowing prisoner exchanges.

These arguments, as one might expect, didn't do Wirz a whole lot of good, and on the morning of November 10, 1865, Henry Wirz was taken out to the courtyard of the Old Capitol Prison and hanged. Photographs of the time capture the event, with the newly completed Capitol dome

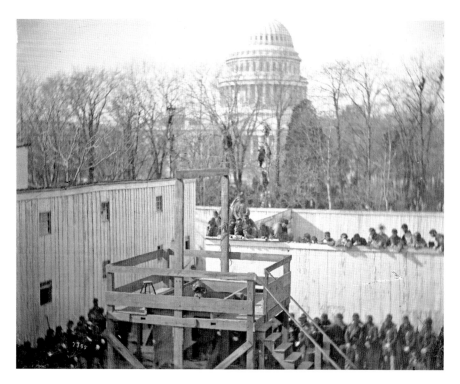

Henry Wirz, the only person executed for war crimes after the Civil War, was hanged just outside his jail cell at the Old Capitol Prison. While not open to the public, many spectators got around this by climbing nearby trees and buildings. *Alexander Gardner, Library of Congress, Prints and Photographs Division.*

in the background and spectators climbing trees to get a good view of the event.

Wirz would stick around as one of many ghosts to walk the halls of the Old Capitol Prison, but he's unique in that he kept on after as well. While the destruction of the building and the construction of the United States Supreme Court on the site put other ghosts to rest, Wirz seems to have lingered. Not long after it was opened, in October 1936, the *Washington Post* reported that the ghost of Henry Wirz "may be seen wandering the corridors of the marble palace of justice, looking for his flown conscience."[26]

A Mysterious Violinist

But to go back to the time following the Civil War, the prison was sold back to private parties and turned into townhouses. In 1921, it was purchased by the National Women's Party, which used it as its headquarters as it campaigned for the right of women to vote and subsequent battles for equality. The organization occupied it until the federal government once again claimed it in 1929, forcing the NWP to its current location at the historic but regrettably unhaunted Sewell-Belmont House just up the street.

But while they inhabited the Old Capitol, members of the National Women's Party recalled numerous strange occurrences. On the anniversary of Mary Surratt's hanging, an outline of a female figure would often appear at an upstairs window. Loud, almost maniacal laughter could be heard from the third floor, attributed to the notorious Belle Boyd. The pacing of

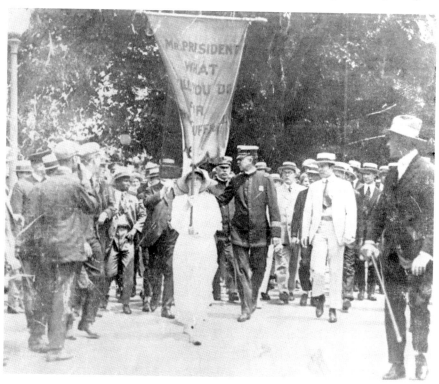

Mabel Vernon of the National Women's Party marches to the White House. Ms. Vernon lived in the apartments of the Old Capitol Prison and was a repository for stories of unexplained phenomena. *Harris and Ewing Collection, Library of Congress, Prints and Photographs Division.*

unseen spirits, the rattle of manacles and the slamming of iron doors would interrupt their sleep.

But one of the most specific stories was related by Mable Vernon to John Alexander in *Ghosts, Washington Revisited*. Ms. Vernon was a tireless campaigner for women's suffrage and had even smuggled in a banner under her skirt to a 1914 presidential address to Congress. In her waning years, she related a tale of a violin owned by a fellow member of the party.

The violin was kept in the parlor and rarely used. Then, to their surprise one evening, several of the ladies heard the sounds of a Civil War–era melody. Some of the older members remembered it from their childhood, and it was described as "the type of melody likely to have been a favorite in a prison where sad, lonely, and homesick soldiers wondered if they would ever be free to live and love again."

The women assumed that someone had picked up the violin and started playing. Curious as to whom, they made their way to the parlor. They opened the door and were shocked to discover an empty room. The violin had not been moved, and its bow hung in its usual spot. A search of the house, and even the surroundings, revealed nothing. No one ever discovered the identity of the mysterious violinist.[27]

Alexander recalls another tale on the grounds of the building. One morning in the early 1920s, a congressman woke before dawn to tackle some paperwork. As he strolled in to work just at sunup that foggy morning, he was startled to come across a soldier marching back and forth in front of the Old Capitol. As he got closer, he saw that he had a Civil War–era uniform and a rifle over his shoulder. Curious, the congressman approached. Just then, the sun broke through the gloom and the vision disappeared, right in front of the entrance to the old prison.

TIME TO READ FOR MR. FOLGER

Across East Capitol Street and behind the Supreme Court is another marble-clad building all too common in Washington, D.C., although this one happens to be privately owned. The Folger Shakespeare Library houses the largest collection of William Shakespeare's works in the world, including 82 of the 228 First Folios believed to still be in existence.

The library, and specifically the Tudor-style, oak-paneled reading room, is haunted by the ghost of Henry Clay Folger. Folger was an avid collector

of Shakespeare's works, and he quietly purchased the row of houses that once stood on the site. The Library of Congress had its eyes on the row as well for an expansion, but when you're the chairman of Standard Oil, you have a little pull in this town. In 1928, Folger persuaded Congress to pass a resolution allowing him the use of the land. Unfortunately, he died shortly after the cornerstone was laid in 1930, leaving his wife to spearhead his efforts to complete the library soon after.

The collection's worth is beyond measure and is, of course, guarded. Late at night, security guards have reported turning lights off on their rounds in the Reading Room only to have them flipped back on during the next round. It is the ghost of Henry Clay Folger, finally able to peruse his collection in the magnificent building he didn't live to see completed.

THE LOST STASH OF GOVERNMENT BONDS

Heading back to the Capitol, we come across the impressive Jefferson Building of the Library of Congress. Mercifully, the designers took a rare break from the ubiquitous white marble of Washington, and the building is clad in gray New Hampshire granite. For once, gray stands out.

The Library of Congress was originally exactly that, a reference library for Congress itself. As such, it was housed in its own space in the Capitol. Changes came quickly to the new library. The British used books from the Capitol to start the fire that burned it down in 1814. Thomas Jefferson sold his collection to replace them shortly after, but another fire in 1851 destroyed much of that. Perhaps the farthest-reaching change to the Library of Congress and its mission came in 1870.

That's when Congress passed the Copyright Act of 1870, which made the Library of Congress the central copyrighting authority for the entire country and furthermore required all authors wishing to have a book copyrighted to send two copies to the library. The collections increased tenfold seemingly overnight, and Congress was forced to give up on the convenience and build larger accommodations across the street.[28]

The Congressional Library Building, as it was known at the time, was a great triumph, symbolizing a nation that had put the trauma of the Civil War behind it and was confident enough to take its place on the world stage. But underneath the decorative glamour of the new building were sensible precautions. Libraries in general had a reputation for disastrous fires, as

Above: The Copyright Act of 1870 caused such a boom in library holdings that a new building was required across the street. Not all the ghosts made the journey. *National Photo Company, Library of Congress, Prints and Photographs Division.*

Left: Fires plagued the Capitol since it was first built. This one in 1930 largely destroyed the House Document Room. *National Photo Company, Library of Congress, Prints and Photographs Division.*

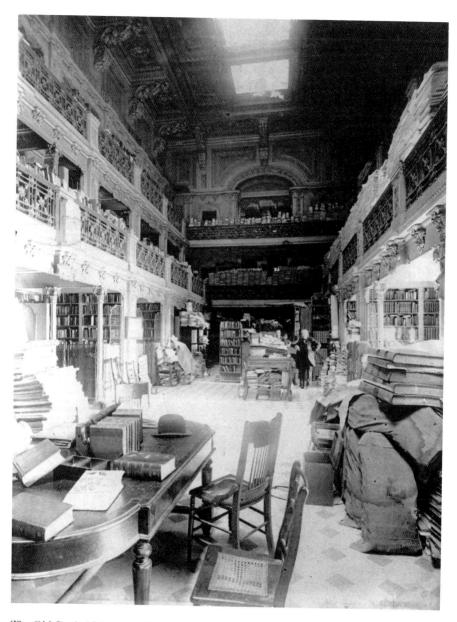

The Old Capitol Library, before these volumes were moved to the new building.
Somewhere in these stacks is $6,000 in government bonds. *National Photo Company, Library of
Congress, Prints and Photographs Division.*

thousands of volumes of dry, dusty books and manuscripts somehow go together poorly with candle light and even gas lighting. The new building was built to be as fireproof as possible, even being the first government building in Washington to be designed from the ground up with electricity.

The library moved in in 1897 but failed to properly relocate its ghost along with its books and manuscripts. One "amiable old gentleman who used to catalogue books" was in the habit of stashing retirement savings in the lesser-read manuscripts. He had saved up something on the order of $6,000 in United States government bonds but unfortunately had a stroke before he could recover it. For some time, he attempted to convey to his family his interest in having them take him back to the library, but to no avail. He passed away, and when the books were moved to the new library, the money was found. Unfortunately for his family, without proof of the loss, they were unable to claim the bonds. The old gentleman continues to haunt the subbasement of the Capitol, searching for the volumes that hold his money.[29]

GHOSTS OF THE JEFFERSON BUILDING

Another ghost is found in the energetic "Mr. Twine," who was nothing if not a dedicated civil servant; he passed away shortly after the move to the Jefferson Building. He occupied a booth in the basement of the building, and his job was to stamp the books as they came in with a mixture of alcohol and lampblack, marking them as library property. When he passed away, the afterlife must have held no interest for him, as he "can not seem to keep away from his old job of stamping the Government's mark on shadowy books."[30]

Additionally, there is the mysterious and helpful policeman. The library can be an odd place at times. Just a few steps away, outside the doors, is the hustle and bustle of Congress, the noise of the city streets and a very busy world. But in the library, especially among its more obscure Reading Rooms, it's easy to get sucked into a medieval manuscript or long-forgotten map. Over the years, researchers have done this, only to find that the library has closed around them. Hurrying out, they find a Library of Congress police officer, who graciously escorts them out. His uniform and speech strikes the researcher as a bit old-fashioned, but much of the library is like that. But upon reaching the exit, they're startled to be told by the officer at the door that no such policeman exists and that they haven't worn that particular style of jacket or coat in years.

THE TRIALS AND TRIBULATIONS OF JUDGE HOLT

Farther south of the Capitol lies the grand and imposing House Office Buildings. The first to be built, the Cannon building, was once the site of a grand and imposing mansion on the corner of New Jersey and C Street SE. Built in the late 1790s, it had most recently been the home of Joseph Holt.

Born and bred in Kentucky, Holt came to Washington in the Buchanan administration as postmaster general and, briefly, secretary of war. When war broke out, he joined the army; President Lincoln, eager to rally support in the border states, appointed him judge advocate general, the highest-ranking legal officer in the army.

As such, he participated in two of the most celebrated cases at the end of the Civil War. He was the lead prosecutor in the government's case against Henry Wirz, the Andersonville prison commander discussed earlier. In his moving closing statement, he condemned Wirz with a blistering critique: "This work of death seems to have been a saturnalia of enjoyment for the prisoner, who amid these savage orgies evidenced such exultation and mingled with them such nameless blasphemy and ribald jest, as at times to exhibit him rather as a demon than a man."[31]

But more importantly, in a case that would shape the rest of Joseph Holt's life, Holt prosecuted the eight Lincoln conspirators. Little sympathy or doubt of guilt was wasted on seven of the defendants, with the possible exception of Dr. Samuel Mudd. But Mrs. Surratt, in no small part due to her gender, was a different case. If convicted, she stood to be the first woman executed by the federal government.

Furthermore, the case against her was tenuous, especially compared to the clear guilt of several of the others. Much of the prosecution's case rested on the testimony of a Louis Weichmann, a resident at the Surratt boardinghouse. Nevertheless, Surratt was found guilty and sentenced to hang. Five of the nine military judges signed a letter of clemency, urging President Johnson to commute the sentence to life in prison. Popular opinion held, backed up by Johnson's explicit agreement, that Holt never showed the president the letter. Certainly, Johnson did not sign it. It's a debate that would continue well after Holt and Johnson went to their graves.

In an ironic trick of fate, Mary Surratt and Henry Wirz were buried near each other, in Mount Olivet Cemetery, on the then outskirts of the city of Washington.

Joseph Holt never recovered from the trials. He remained judge advocate general until 1875, but Kentucky was no longer his home. Upon his death, a tale was told that his former father-in-law, Governor Charles A. Wickliffe, had visited the grave of his daughter, Margaret Wickliffe Holt, who had died before the war. As his fingers traced the name "Margaret" and "Wickliffe," he wept bitterly. But when he came to "Holt":

> *The fingers of the old man do not tremble now. They trace the four letters, and the face so softened by emotion a moment ago grows hard and stern. He has no memory of the time when he loved the bearer of that name. He only feels that the name is a desecrating blot upon the tablet that tells the virtues of the departed members of his race. With his own hands he wields the mallet and chisel and effaces the hated name.[32]*

Joseph Holt became increasingly withdrawn. He lived alone, with a single servant to keep him company. The great house became increasingly

Joseph Holt was never able to let the cases he tried during the Civil War go. He became increasingly reclusive in his house, just steps from the Capitol. Today, it is on the site of the Cannon House Office Building. *Brady-Handy Photograph Collection, Library of Congress, Prints and Photographs Division.*

gloomy, and "the once well-kept garden became a mess of tangled undergrowth, forming an almost impassible barrier to the entrance." No visitors were seen coming and going. Holt would rarely emerge, and when he did, he would interact with no one.[33]

Yet he compulsively ordered and reordered his papers, rearguing his great cases to himself. Even as he lost his vision, he insisted on arranging them so that his servant could summon any he might need. His only interaction was in dictated letters, defending himself and his actions in the Surratt case. He even wrote a pamphlet, *Vindication of Judge Advocate General Holt From the Foul Slanders of Traitors, Confessed Perjurers and*

Suborners, Acting in the Interest of Jefferson Davis, which, as the name might imply, did not indicate a great deal of remorse for his actions. He waged a lonely and silent war with those who thought that he had mistreated Mrs. Surratt, especially with John T. Ford, the owner of Ford's Theater, who became a champion of Surratt and a harsh critic of Holt. Ford had been briefly imprisoned with Louis Weichmann and had become convinced that Weichmann had not been reliable when he testified.

Eventually, after thirty-four years alone, Holt fell down the stairs in 1894 and died as a result shortly after. The house was tied up in a spectacular probate case, with a mysterious, fire-singed will that was mailed a year after his death with no return address, naming two distant goddaughters as beneficiaries. The case made it all the way to the Supreme Court, which, ironically, was geographically closer to the Holt House than the initial District Court, and the estate was finally disposed of.

The house was lived in briefly afterward, but the new residents could not find peace in it. The upstairs library had an unusual chill about it, and the sound of pacing could be heard for hours on end. Presumably, it was General Holt, relentlessly pounding away at his cases, arguing them to himself in death as well as life.

Naturally, the new owners raised little objection when the house was purchased by Congress to build the first House Office Building, now known as the Cannon Building. It was razed in 1904, but that was not the last Capitol Hill saw of Joseph Holt.

Soon after, Holt would be seen walking the few blocks up 1st Street SE to the Old Capitol Prison, dressed in his blue uniform, cape pulled tightly about him. Was it to continue his debate with John Ford? Or was it to confront Mary Surratt directly and find out the truth? Perhaps he wanted to see the ghost of Henry Wirz one last time, to confirm that he had gone to the gallows as Holt wished? Maybe all of them, and many more, for there was no shortage of people Holt prosecuted held there.

PART III

HAUNTED HOUSES OF HISTORIC CAPITOL HILL

C apitol Hill may mean Congress and its workings in the rest of the country, but for more than fifty thousand people, it's their home. People have been born and raised and died on the Hill for more than two hundred years, so it's natural that some of them have stuck around.

Until the Civil War, Capitol Hill was a crescent-shaped strip of houses and shops running from the Capitol down Pennsylvania Avenue and 8th Street SE to the Navy Yard and surrounding streets. Today, this forms the core of the Capitol Hill Historic District (although that itself extends much farther) and contains plenty of haunted houses to talk about.

THE FADED GLORY OF DUDDINGTON MANOR

No place epitomizes the soaring hopes and crushing decline of a young Capitol Hill like Duddington Manor. It was built, twice as it would turn out, by Daniel Carroll of the ridiculously influential Carroll family of Maryland. Duddington had been a working tobacco farm almost one hundred years before the first tea was chucked in Boston Harbor, and it stretched from what is now north of the Capitol down to the river. Daniel Carroll found himself in the enviable position of being a wealthy landowner just feet from the Capitol. As a point of fact, the Capitol was built on his land, and he expected a rather steep increase in value

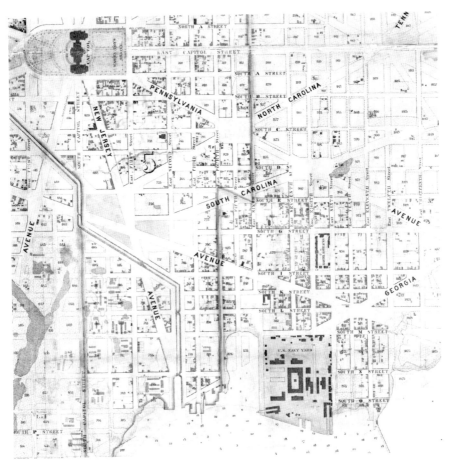

Up to and through much of the Civil War, Capitol Hill was largely centered on the Capitol Building and the Navy Yard, as well as the stretch between them. *A. Boschke, Library of Congress, Geography and Map Division.*

for the remaining plots. As Carroll's cousin, also named Daniel (the overwhelming majority of Carrolls are named Daniel or Charles), was one of the commissioners responsible for supervising the layout of Washington, we can imagine that he contained his surprise at his good fortune.

In the enthusiasm of early Washington, Daniel Carroll saw a future where his house would be a center of social life and he would enhance the family fortune by selling other chunks of newly valuable land. He quickly started construction of a grand manor but ran into a bit of a problem. He had selected a site that

lay partially on what Peter L'Enfant had intended to be New Jersey Avenue, one of those impressive radial roads emanating from the Capitol. Whatever genius L'Enfant possessed as a designer, he lacked as a politician, and failing to convince Carroll to relocate his manor, he simply had it torn down.

Destroying your supervisor's cousin's house is generally considered a poor career move, whatever the merits, and L'Enfant quickly found himself pushed aside as the designer of Washington, for this as well as other reasons. Having thoroughly lost the war, he did retain victory in the battle, and New Jersey Avenue runs today exactly where L'Enfant envisioned. Daniel Carroll resumed construction a few feet to the east on a square bounded by E Street, 1st Street, 2nd Street and South Carolina Avenue SE.

Duddington became the bright light of Capitol Hill society, though a small advantage in a comparatively dark sky. Years later, when its glory had long faded, it would still be remembered fondly:

It was a palace, complete and tenanted, in the midst of a cultivated park, when the Capitol and the President's house were but a story high and the grounds

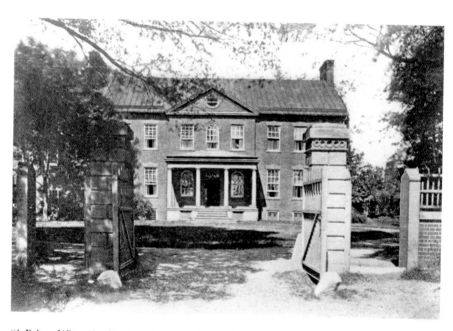

"A Palace When the Capitol Was But a Story High." Duddington Manor was the center of Capitol Hill's social universe for decades. Unfortunately, society moved elsewhere, and Duddington was left to deteriorate. *Historic American Buildings Survey, D.C., Library of Congress, Prints and Photographs Division.*

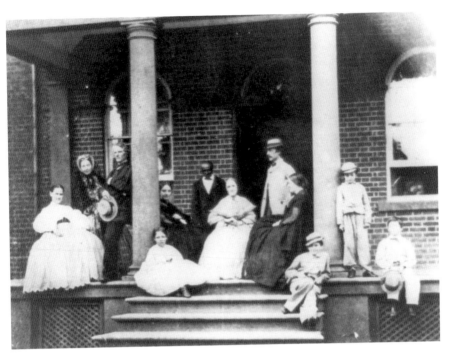

Daniel Carroll and his family. His daughters would be the last residents of Duddington, before selling the house to developers in their old age. *James M. Goode Collection, Library of Congress, Prints and Photographs Division.*

about them nothing but commons. It was the boasted edifice of the Capital, when the older buildings which we now call old were undreamt of; and if in the midst of the modern buildings by which it is surrounded, it's style appears quaint and old fashioned, it possesses what modern architecture, for the most part, cannot claim—great strength and durability, ample room and comfort. It looks, even now, in its stately grandeur, as though it could give most structures a hundred years start in the race for survival, with chances two to one in its favor.[34]

Unfortunately for the growth of Capitol Hill, Carroll land banked the other plots of land, holding out for more money. Developers simply purchased land farther to the west, leaving Capitol Hill sparsely developed, and Carroll never realized the fortune he could have. Rich in land but without an income, Carroll was unable to pay the property taxes on most of his property, and he lost virtually everything but Duddington. He lived there with his daughters and their slaves until he passed away before the Civil War.

The unmarried daughters remained until they sold it in 1886 to developers who tore it down and built row houses on the site.

But as the house and all it stood for faded away, neighbors began to speak of haunted happenings. The old-timers told the young of the grand balls, when they would watch carriages drop off elegant ladies and gentlemen at the brilliantly lit mansion. Some would claim to still see the carriages come, if only in the gloom of night. Perhaps it was hard to reconcile that image with the forlorn aspect it portrayed. The echoes of the past would reverberate down the years, though, and in 1893, the *Washington Post* reminisced about Duddington as an "old, rambling mansion just south of the Capitol, where the shade of a young girl killed on the night of a debutante's ball is still supposed to wail and wander through the deserted halls."[35]

A Contemporary Haunted House

Just a few blocks from where the ghosts of Duddington are presumably at rest is a far more active haunted house. Peter Waldron lives at 218 2nd Street SE and has since 1974. It's a perfect example of a typical Capitol Hill row house, unique in detail but similar to thousands elsewhere around the Hill. Built in the 1880s, it has the typical ground entrance to the first-floor level, known as an English basement, and an iron staircase to reach the main residence. Peter, in fact, was a renter in the English basement for many years before he purchased the house in the 1980s after the death of the previous owner, Fred Coker, who worked across the street at the Library of Congress.

Perhaps this connection explains the very odd event that happened to Peter Waldron around Christmas in 1990, a story that eerily echoes the poor librarian at the Library of Congress discussed earlier. Peter worked in the restaurant business, and this was naturally a very busy time of the year for him. Having a large amount of cash, $5,000 to be precise, to deposit at the bank, he was unable to do so with the crush of work going on. He placed the money under some books on the third shelf of a built-in bookshelf in the front bedroom of the house, well hidden, until he had time to deal with it.

When New Year's passed and he had some breathing room, he went to retrieve the money, but it was nowhere to be found. Peter is nothing if not careful, and he remembered specifically where he had put it. Nevertheless, he searched the entire bookshelf top to bottom. He searched the similar built-in floor-to-ceiling bookshelf on the other side of the room from top to

Number 218 2nd Street SE has seen some strange things, including disappearing money eerily similar to the stories from the Library of Congress. *Photo by author.*

bottom as well. He took the books off the shelf, dozens if not hundreds of them, and searched them page by page. His wife, certain that her husband just misplaced the money, took it upon herself to exhaustively search the premises. Eventually, they yielded to the inevitable conclusion that Peter, despite being a person who can summon the dates of random events from memory, had somehow forgot where he put the envelope of cash. Nevertheless, he continued to search throughout the years, at least half a dozen times, unable to just let it go entirely.

That is, until May 16, 1998, a date Peter remembers vividly. It was a hot spring day, and he had plans to buy an air-conditioning unit for the back bedroom. He was sitting in the rocker in the front bedroom, not at all worried about the lost money, when an undefinable "something" made him get up, walk to the exact spot where he had left the money and look under the book on the third shelf up. There it was, the envelope full of $100 bills that he had left. Today, with no small sense of irony, a copy of John Alexander's *Ghosts: Washington's Most Famous Ghost Stories* shares a spot on the very shelf. Needless to say, Peter kept the money on him until he could make it to the bank. No sense trusting the house to get its hands on it again.

But this wasn't the first time that Peter felt a presence in the house. On a Sunday evening in February 1980, Peter came home exhausted from a busy weekend at the restaurant. He started a fire in the fireplace, sat down on the sofa and dozed off. After about an hour or so, he had a feeling that there was a person in the room. He awoke with a start to find that there was indeed someone at the foot of the sofa. It lingered just long enough so he could see it

was a man, not a woman, and then disappeared. Seconds later, Peter found that the fire had spread from the fireplace and the entire room was alight. Smoke filled the room, and Peter and his German shepherd, Morpheus, were barely able to make it out alive.

The strange occurrences at 218 2nd Street didn't stop there. When loading his car for a predawn road trip, Peter came back inside the house to find a rarely used second-floor room with the door open and the lights on. In fact, doors routinely open or close, so much so that one tenant couldn't take it any more and moved out. Then there was the time Peter was in the shower. He heard someone

A painting of 218 2nd Street. *Photo by author.*

in the house, which was unusual as he lived alone by this point. He stepped out of the shower and there, written in the steam of the fogged-up mirror, was the infinity symbol, a sideways "8." Incidentally, this symbol carries great meaning in tarot cards, where it is known as a lemniscate. It serves to "remind us of the infinite nature of our spirit."[36]

Finally, there is the painting. Peter loaned a friend, Maureen McCormack, about $1,000 in the late 1980s. Unable to repay, she had an artist friend paint a portrait of 218 2nd Street. Peter enjoyed the painting, hanging it on his dining room wall, but was curious about one point: why had the artist added a figure in the second-floor window? Maureen was also curious and went back to the artist. The painter was taken aback and knew of no such figure. Somehow, she had painted the unmistakable face and upper body of a person. It's hard to ascertain much detail, but you can tell that it is a man, not a woman, peering from the room the money disappeared from for seven and a half years.

OLIVIA'S GHOSTLY HOUSEMATE

Nestled in one of Washington's oddly shaped triangular blocks is Capitol Hill's oldest existing house, The Maples. It was built in 1796 by a British merchant by the name of William Mayne Duncanson, who had visions of expanding his booming East India trade along the banks of the Anacostia. Unfortunately for Duncanson, the navy grabbed the prime spots along the river, and his real estate holdings went belly up. He lost the property in 1800 and died a pauper a few years later.[37]

The Maples is poorly matched to its name among the hustle and bustle of urban life two blocks from Eastern Market, but at one point this was a wooded area known as "Maple Square." Traces of this are found in an 1840 account by third Librarian of Congress and Hill resident George Watterston. In an unpublished manuscript, he refers to it as "a fine brick house in the woods between the Capitol Hill and Navy Yard." As so often happen with these things, in local lore the name Watterston was swapped out with Washington, and for years people believed that George Washington stayed here, even though he is unlikely to have even visited.[38]

But with or without George Washington, The Maples has seen quite a bit. Wounded British soldiers were purportedly left here to recuperate after the burning of Washington in 1814. Francis Scott Key purchased the property shortly after and, for lack of a better word, flipped it not long after that. After

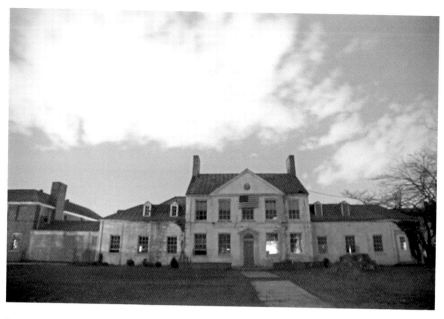

Referred to as "a fine brick house in the woods," The Maples is today the oldest existing house on Capitol Hill. *Photo by Maria Helena Carey.*

The Maples is closed off right now, but it is in the process of being restored as condos. *Photo by Maria Helena Carey.*

proceeding through a series of distinguished owners, The Maples became Friendship House in 1937, a settlement house serving children of Capitol Hill. That era came to an end in 2008, and the house is currently being restored as condos. After almost eighty years, people will live in The Maples once more.

We can certainly hope that new residents of The Maples keep Capitol Hill's proud tradition of quirky and interesting residents going, but it's unlikely that any will be able to match the indefatigable Emily Addison Briggs. Mrs. Briggs came to Washington during the Civil War with her husband, one of thousands who saw opportunity in the sweeping away of old political structures. John Briggs had been a newspaper publisher in Iowa and, at least according to him, friendly with Abraham Lincoln through Republican Party circles. With the new administration, he came to Washington and wrangled an appointment as assistant clerk of the House of Representatives. Emily was never one to sit idle, and after a short time in the city, she took up the cause of young ladies who had filled clerking jobs while men went to war, defending them in an anonymous letter to the

Emily Edson Briggs, from her obituary on July 4, 1910. She was an iconic figure on Capitol Hill and often known simply by her pen name, "Olivia." It's no surprise that she shared her house with a ghost. *From the* Washington Times, *Library of Congress, Chronicling America.*

Washington Chronicle. She impressed the editor with her writing style and was hired as a correspondent at his other paper, the *Philadelphia Press,* under the pseudonym "Olivia." Olivia would continue for almost twenty more years, becoming the first woman to report from the White House and be admitted to the Congressional Press Gallery. Her witty observations and pointed columns were collected and published in 1906 as *The Olivia Letters.*[39]

Olivia (as she was increasingly called in real life as well) and John purchased The Maples in 1872, and John passed away shortly afterward from tuberculosis. Undaunted, she entertained lavishly and soon gracefully managed the transition from correspondent to lady of society. But despite her perfectly coiffed hair

and fashionable dress, she retained a strong social conscience. When leaders of Coxey's Army, a populist march on Washington in 1894, were arrested, she bailed them out. She proposed a university of the United States that would focus on technical training because "there are enough of our college-bred boys now rolling around the plains as cowboys."[10] Upon her death, she willed the house to form a school for girls, a vision that never materialized.

Even her living style was somewhat eccentric. She is believed to have owned the first Turkish divan in America, purchased from the ambassador himself.[11] She once hosted a gala where guests were "presented with a grasshopper-green swastika, which was worn throughout the festivities as a talisman." The symbol did not mean then what it does today but instead was regarded as an idealistic feature evoking the spirit of Native Americans.[12] She remained a fixture in the house and neighborhood until her death in 1910. Perhaps it's not too surprising that a wonderfully eccentric lady living alone in a "stately house of distinguished occupancy" should come across a ghost.

A 1927 account tells the tale of Mrs. Briggs's encounter with the supernatural. Shortly after her husband passed away, Mrs. Briggs began to feel a presence, another soul sharing her house. It seemed centered on a bedroom and was often accompanied by strange, unfamiliar music wafting through the house.

Mrs. Briggs identified one particular bedroom as the "abode of a most genteel and benign female ghost" and grew accustomed to sharing her house with the presumed former resident. Olivia was nothing if not avant-garde, and a lady who had so little use for Gilded Age gender barriers apparently felt that death was not a hindrance to social relationships either.

Time passed, and Mrs. Briggs and her ghost cohabitated quite nicely. At first, the sounds of weeping would fill the house, but this simply fascinated the intrepid journalist in Olivia, and she grew accustomed to the forlorn spirit. Over time, they grew comfortable with each other, two ladies living together as the years passed by.

One morning several years later, Olivia awoke to an emptiness in the house, a sense that something was missing. Indefinable at first, she felt drawn to the bedroom. Opening the door, she noticed that while the bed was made up as usual, it was obvious that someone had lain on it recently. The covers were slightly mussed, and the pillow had an indentation as if left by someone's head. Mrs. Briggs examined the scene and was astonished to find a single white pearl left in the depression.[13]

It was the last anyone saw of the ghost, and years later, her daughter remembered that Mrs. Briggs always felt that the ghost had made peace with her situation and moved on, leaving the pearl as a final gift. It was a

comforting tale, this sad spirit finding comfort and solace, but the question remained unanswered: just who was the ghost of Maple Square?

The earlier account left it at that, but we have an obvious answer. A few decades before the Civil War swept the Briggs into town, Major Augustus A. Nicholson purchased the house and moved in with his large family. The good major had recently been appointed as the quartermaster of the Marine Corps, placing him in charge of marines' supplies and logistics. He moved the household down from New York, settled into the house and soon became a fixture in Washington society.

Capitol Hill traditionally lagged behind Georgetown and other neighborhoods toward the northwest of the city, and this worldly, well traveled and outgoing couple made quite an impression on the rather quiet neighborhood. A 1901 account reflected on Major Nicholson as a "man of very aristocratic character, of fine taste, and what the French call a bon vivant" whose entertainments were "attended by the most fashionable people in the District."[44]

Whatever the effect of his social graces on the town, Major Nicholson was losing popularity at home. His wife, Helen Bache Nicholson, was of the Lispenard family of New York, a family well off enough to have their own vault in the Trinity Church Cemetery on Broadway, a few blocks south of, well, Lispenard Street. The two had met when then Lieutenant Nicholson was stationed in New York. Helen had loyally followed her husband from duty station to duty station, bearing eight children (five of whom lived) along the way.

The pace continued in Washington, and shortly after the birth and sudden death of their tenth child, rumors started to swirl about the couple. Major Nicholson was seen consorting with Sally Carroll of, naturally enough, the Carrolls of Duddington, just down South Carolina Avenue. He, of course, denied that anything untoward was happening, and whether anything was or not, Helen and he did manage to conceive an eleventh child. However, neighbors around town began commenting on Mrs. Nicholson's "sudden fits of insanity." Whether this was from the death of their more recent child, the stresses of her pregnancy or her husband's presumed affair, history does not relate, but it's safe to say that Mrs. Nicholson had a full plate on her hands.[45]

Virginia Bache Nicholson was born on August 12, 1845, and almost one month later, on September 16, Helen visited a friend on 3rd Street and Maryland Avenue NE, shooed the friend's child out of the room and cut her own throat with a dinner knife.

Major Nicholson somehow managed to rise above his grief and married young Miss Carroll, the same lady he had denied consorting with, a bare six

months after his wife's death. They eventually moved out and built a grand house of their own, closer to Duddington.

So perhaps we can find solace that Helen Nicholson found a better friend in death with Olivia Briggs than she had in life with her husband.

The Spooky Police Station

Just a block away from The Maples is a fully functioning relic of a time gone by, the Metropolitan Police Department's First District Substation. MPD, as D.C.'s local police force is colloquially referred to, traces its origins back to the Civil War, when rapid government expansion, an incoming horde of unscrupulous opportunists and not a few drunken soldiers made the existing system of a fifteen-man auxiliary watch untenable. Today, MPD is a thoroughly modern crime-fighting organization, but the 1D-1 Substation harkens back to a different time—when patrolmen walked their beat, checking in via call boxes still visible on many city streets, and used whistles to call for backup. Local residents are largely familiar with it as the place to go to get parking permits for out-of-town residents, and a step inside gives a whiff of Joe Friday. It's a throwback, a historic building still in active use, not gussied up with new wood paneling, with an actual desk officer, slightly bored and almost always helpful, there to answer questions.

Ghosts and cops have a long, symbiotic history together. In days past, and today to an extent, they would often be the only two classes of beings walking around deserted city streets at two o'clock in the morning. Many a ghost has been sighted by a police officer, and even when the ghost appears to someone else, reporters instantly turn to the officer on the local beat for confirmation. More often than not, the cop is a believer and can regale even cynical reporters with prior instances of apparitions, streets he won't walk down and other dark doings of the night.

So it was no surprise a few years ago when a local MPD officer (who has asked to remain nameless) told a tale of a mysterious occurrence at the substation. It happened, as these tales so often do, on a dark and stormy night, when the officer was on desk duty at the front door. The station was equipped with a closed-circuit TV camera, naturally, and just when the officer felt that he was losing the long war against drowsiness, he noticed another officer on the TV, which was odd, as he was mortally certain that he was alone in the building.

Now known as the Metropolitan Police Department's First District Substation, this building was once home to the Fifth Precinct. Keep your eye open for a turn-of-the-century police captain. *Photo by Maria Helena Carey.*

It was hard to see, but the phantom officer didn't look like any of the police officers then assigned at the station. What's more, he was wearing an anachronistic jacket and a long coat, seemingly dripping with rain. Via camera, our confused and slightly apprehensive officer tracked the mysterious being as he headed out a side entrance and disappeared into the gloom. A search was made: the side door was still locked and showed no sign of being opened recently, and there were no wet floors that you might expect from a dripping coat. Playing back the tape revealed only the ordinary quiet of a virtually empty police station in the wee hours of the morning.

The officer had no explanation of the tale and has often managed to convince himself that it was all in his head. But the question lingers: who was the phantom officer?

Well, there's certainly a candidate that fits the bill. On the evening of March 5, 1909, at 7:45 p.m., policeman John W. Collier boldly walked into what was then the Fifth Precinct station house and shot the precinct commander, Captain William H. Mathews, five times, emptying the last three rounds directly into his head. Captain Mathews's deputy, Lieutenant J.L. Sprinkle, and two other officers instantly wrestled Collier to the ground, but

the damage was done. A doctor was summoned, but he could only confirm what the officers already knew: Captain Mathews had been ruthlessly killed without warning by one of his own officers.

Collier offered no resistance nor defense. "I shot him, all right, and I'll give my reasons later. I was rational and sober, and there was nothing wrong with me," he calmly told Lieutenant Sprinkle as he was taken to the District Jail.[16]

In the coming days, some semblance of a picture gradually emerged of the events of the fifth and before. Captain Mathews was known as a by-the-book cop, a "strict disciplinarian," as the *Washington Times* put it, but he was later accused by defense attorneys of being "quarrelsome, vindictive, and violent." Collier was a slacker who had been before the trial board (a disciplinary board for police officers) nine or ten times. His mother defended her son but offered what was perhaps not the best defense: he felt he was being persecuted for being late.[17]

On the day of the murder, Collier was supposed to go on duty at midnight. A 4:00 p.m., he called in sick. The captain had had enough and told him to come in to the station so that he could see if Collier was sick or not. Just past 7:00 p.m., Mathews received another phone call from Collier that made him turn red and slam "the receiver on the hook with such vigor that the telephone nearly overturned." Collier showed up about half an hour later, talked to no one and walked by the other officers, who nudged one another and whispered, "He'll get his when the captain sees him." Seconds later, the shots rang out.[18]

Collier testified several months later that this was a case of self-defense. He said that the captain had told him in the telephone exchange, "I wouldn't give 15 cents for your chances when you come into the office." Upon his arrival, the captain told him that his goose was cooked, to which Collier replied, "I think you have another thing coming, Captain." Then, according to Collier, Captain Mathews muttered, "Damn you, I'll get you for that," and reached toward his hip pocket. Thinking that Mathews was going to shoot first, Collier fired and killed him.[19]

The trial was a particularly tense affair, as at one point the defense attorney took a swing at the district attorney. The assistant district attorney jumped between them and got a punch in the face for his efforts. The fight was then broken up by a police officer and, believe it or not, the defendant. Perhaps that swung the jury a bit, or perhaps they found his story plausible, as Collier was found guilty of only manslaughter and was sentenced to fifteen years in prison.

Is Captain Mathews the mysterious ghost seen on the video cameras? Who knows, but to answer the inevitable question, it was cold and clear out on the night he was murdered, although Washington was recovering from a snowstorm so intense the night before that it drove President Taft's inauguration indoors. So perhaps it was melting snow on the overcoat?

OLD HOWARD

The area of Capitol Hill around the station house was middle class, but as you traveled farther south, especially before World War II, you could trip and fall down the social ladder quite quickly. Hundreds of young sailors and marines were housed in the area, and they were not considered among the nicer element of society. The Navy Yard itself was a major industrial facility, employing thousands of mechanics and other workmen. And these were the respectable element of the area, those who had gainful employment and responsibilities. The area teemed with a tougher crowd, and the vicinity of the Navy Yard was not a place for strangers to go, especially after dark.

Today, 8th Street SE, now cleverly rebranded as Barracks Row, is booming with new and innovative restaurants and stores, but at one point it was a rather rough stretch of town, with bars and saloons tending to the Yard workers. The narrow streets on either side were lined with cheap frame houses and even flimsy shacks, not the respectable brick-and-stone townhouses of the nicer parts of the Hill.

It's hard to tell this today, walking through what remains. Most of it was torn down after World War II to make the SE-SW Freeway and housing projects, which in turn have been torn down. The alley shacks are long gone, and the few remaining wooden houses are quaint and well maintained. You're far less likely to run across a drunken lout these days, and if you do, he's most likely a Hill staffer coming out of a martini bar, not a factory worker neglecting his wife and kids.

In this once tough neighborhood, right behind the Marine Barracks, there stands a row of those houses. Some are the original wood. Some have been replaced with brick and stone over the years. Few have any inkling of the excitement that once took place on that block of 9th Street, between G and H SE.

Our story starts on Saturday, October 14, 1871, with an article in the *Washington Star*. It centered on a family, the Boneharts, who had recently

This quiet stretch of 9th Street behind the Marine Barracks was once the home of "Old Howard," a particularly naughty ghost. *Photo by Maria Helena Carey.*

moved into one of the two-story houses. They were renting the place from the widow of a marine named Howard, who had passed away a few months before. Howard was known as a "frightfully wicked man who abused his family and all around him, and finally died blaspheming his Maker and cursing his wife and children." Apparently, Old Howard was no more pleasant in death than he had been in life. Mrs. Howard and the children soon fled, renting the house to the Boneharts.

By now, though, the Boneharts had just about had enough. They had lived here for two months, and "things that go bump in the night" doesn't even begin to describe their experiences. Doors that had been shut and even locked were found open, and open doors closed. A connecting door to an adjoining house, locked for years, was found wide open one morning, to the mutual surprise of the Boneharts and their neighbors. When they were downstairs, heavy tapping would be heard above, and when they were upstairs, they would hear it from below, as if "some one was striking a table with a rattan stick." The back door would rattle and shake, and when securely shuttered, it would be loudly banged on.

And it was getting worse. On the Tuesday before the article came out, their servant girl had gone to bed somewhat late when something happened:

> *Almost asleep she suddenly heard steps softly ascending the stairs, and saw the reflection of what was apparently a lighted lamp, but believing it was some member of the family, she did not trouble her mind about it, until, hearing a heavy groan by the door, which stood ajar, she raised up in bed, and says she saw THE GHOST OF OLD HOWARD!*
>
> *The light in his lamp was at once extinguished, and blue and red streaks of light shot through the room. At one bound she was up and raising a frightful scream, which roused the whole house, she bolted down the stairs, and left the house in her night clothes, the entire family following her. The colored girl could not be induced to return to the house, but Bonehart and his family did, and after they had retired they heard terrible groaning from up stairs. Bonehart persuaded his wife that it was the window shutters swinging in the wind, although he did not believe it himself.*

The servant girl, quite sensibly, made a run for it and found other accommodations, but Mr. Bonehart managed to convince his wife to return to bed. Perhaps he should not have:

> *Very soon the bed in which they were laying began to move out in the middle of the room, and loud groans came from underneath it. This so frightened them that they left the house, and Bonehart went to the station-house, where he told his story. Officer O'Hare at once repaired to the place, and found the family running away from the house. He examined the premises throughout, but could find nothing wrong, and persuaded them to return, promising that he would watch the house. After they had returned he heard the noises and rapping and thought that someone was at the back door, as the knob moved very perceptibly.*

Somehow, Officer O'Hare managed to convince the family to sleep, or at least be quiet, and the family went about their day. But the next night, the noises returned, and Officer O'Hare was summoned again from the nearby police station. One can't help but note that this time he brought a partner, Officer Shelton. They again managed to quiet the family, despite the continuing noises.

The next morning, Mrs. Bonehart, we can only imagine, had heard quite enough of Old Howard, Mr. Bonehart and Officer O'Hare alike and resolved not to spend another night in the house. They decamped to a neighbor's, Mr. De Neal, while Mr. Bonehart was sent to look for new lodgings. The article ends with a somewhat defensive disclaimer

by the *Washington Star*: "We have told the story just as it is related by the Boneharts, their neighbors, and the policeman, and every reader can furnish his own explanation."[50]

But that was not the last the world would hear of Old Howard. John Alexander related in *Ghosts of Washington* that in the early 1900s another family moved in, with similar results. As the young lady went to bed, Old Howard decided to have a little inappropriate fun. He turned off the gas lamp, pulled her covers back and began to pant in a lewd manner. Naturally, the girl screamed and turned the light back on with her shaking hands. A search of the room revealed nothing, but this family moved out a short while later as well.

In yet another episode, Howard tormented a young couple that had moved in. Similar to the occurrence with the Boneharts, he thrust their bed into the middle of the room, although in this case he added a little effect by throwing open the curtains, in full display of their neighbors. The account is vague as to what the couple was actually doing in bed, but as they moved out to avoid facing their neighbors, perhaps there was an element of shame to go with the fear this time.[51]

PART IV

GHOSTS ON DUTY

HAUNTS OF THE NAVY AND MARINE CORPS

If the Capitol Building was one anchor for the emerging neighborhood that shared its name, the Navy Yard was the other. From the Capitol, Capitol Hill stretched down Pennsylvania Avenue SE, hooked a right at 8th Street SE, passed by the thoroughly haunted Marine Barracks and ended up at the neighborhood's second major nucleus, the Washington Navy Yard. Until well after World War II, the Navy Department was the largest employer on Capitol Hill, and much of the development of the southern portion of the Hill is directly attributable to its influence.

Originally, the site (a natural harbor) was envisioned as a shipping port, and the main road connecting the area with Pennsylvania Avenue, 8th Street, was to be a commercial bourse or marketplace. This was to be the mercantile hub of the new Federal City, rivaling the existing trading centers of Georgetown and Alexandria—so much so that the Capitol was largely oriented in this direction.

The navy was a bit of an afterthought in the design of Washington, as it was a post-Revolutionary America, when we had more important things to worry about. But events overseas, namely the Barbary pirates in North Africa and the Quasi-War with France in 1798–1800, forced us to build an oceangoing navy and the infrastructure to support it.

As such, the site for the Washington Navy Yard was personally approved by George Washington, and it was established on October 2, 1799. Without the port, the grand commercial plan never materialized, and Capitol Hill, or at least the southern part of it along the Anacostia River, developed as a navy town.

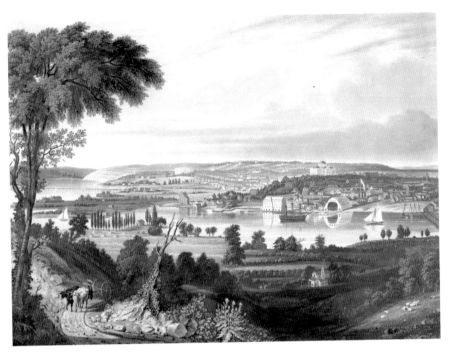

This 1833 print shows both the Capitol and the Navy Yard. Note how undeveloped Capitol Hill is compared to Northwest D.C. *Print by W.J. Bennett, Library of Congress, Prints and Photographs Division.*

THE WATCHFUL COMMODORE

The Navy Yard itself was built and developed—a few times, it would turn out—by Captain Thomas Tingey, a veteran of the Royal Navy who had joined the Americans at some point and distinguished himself during the Quasi-War. The Yard did construct ships, largely gunboats, but its primary purpose was to repair and refit other navy ships as needed, a job that required considerable effort, even without the stresses of war.

But war, of course, came in 1812, and the Navy Yard was swept up in preparations for it. By this point, the Yard had expanded north to its current boundary of M Street SE. The navy used this area to construct housing for senior officers, including Commodore Tingey. Quarters A, lived in by Tingey, is still in use and serves as the home for the Chief of Naval Operations, the most senior officer in the U.S. Navy.

The United States, feeling aggrieved and perhaps a bit salty, declared war on Great Britain in 1812. After some false starts, the young republic found

a few things on which to hang its hat. The navy chalked up some impressive victories at sea; the army was rebuffed in the Niagara campaign but fought well and with great discipline against hardened British regulars; and Andrew Jackson was cracking the whip out west.

But that came to a screeching halt when the British noticed that in all of our impetuous fury, we Americans had neglected to bother with, you know, defending America. The Royal Navy made the Chesapeake its playground, and in August 1814, it decided to teach the upstart Americans a lesson, arguably in retaliation for the burning of York, Canada, the year before. Washington, the capital, was to be burned.

In a bold move, the British sailed up the Patuxent River in August 1814 and marched overland to burn the capital. Captain Tingey, as a former Royal Navy officer himself, was liable to be hanged for treason if captured, but he waited until the last possible moment, hoping that the American forces could rally and stop the Redcoats. However, when he received word that the Capitol was on fire (in fact, he could probably have seen it for himself), he ordered the Navy Yard fired.

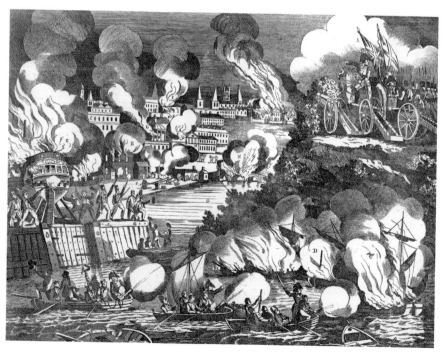

Almost no detail of this 1814 print from a London newspaper is correct, yet it got the point across fairly accurately for its audience. *G. Thompson, London, Library of Congress, Prints and Photographs Division.*

Fortunately, the portion of the Yard along M Street survived, including Tingey's house, although it had been stripped by local looters of every movable object, down to the knobs and locks on the doors.[52] Tingey put the house back in order and continued to live there until his death in 1829, supervising the reconstruction and operations of the Washington Navy Yard. A legend quickly grew, although demonstrably false, that Tingey had lived in the house so long that he willed it to his heirs, quite forgetting that it was government property.

So it's quite natural, considering the close ties that he had with the house, that Captain Tingey would not entirely vacate it upon death. Many residents of Quarters A have felt his presence. The first was in 1853, when the daughter of the Yard Commandant spotted Tingey in the house.[53]

Slightly more recently, in August 1960, the new commander of the Potomac River Naval Command, Rear Admiral Thomas H. Robbins, moved his family into the Tingey House. His pet Doberman, Lucky, reacted poorly to the move, fixating on an empty chair in the drawing room. Lucky began

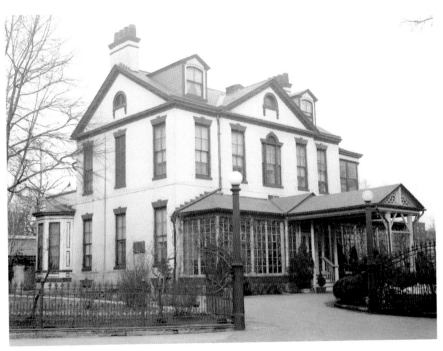

Quarters A of the Washington Navy Yard, commonly called the Tingey House. Captain Tingey can still be seen, often looking down from a second-story window. *Historic American Buildings Survey, Library of Congress, Prints and Photographs Division.*

Commodore Tingey was greatly displeased at the renaming of his beloved Navy Yard to the Navy Yard Gun Foundry. *Detroit Publishing Company, Library of Congress, Prints and Photographs Division.*

whimpering, barking and growling at the chair until the admiral addressed the room, "Good evening, Commodore, we're glad to be living in your house." Lucky settled down but continued to have a contentious relationship with Commodore Tingey, to the point that Rear Admiral Robbins was forced to apologize to his predecessor for his antics.[51]

Commodore Tingey's ghost has continued to inhabit Quarters A, and his presence has been felt by both the senior officers and, more often, their wives, who share the house with him. Except for Lucky, no problems have been reported with him, and he's even been informally cited as a source of strength for them. He's often seen peering down from the second-floor window.

But the Captain also does not feel the need to quietly enjoy the afterlife in repose in the drawing room. Like any good naval officer, especially one with the weight of command on his shoulders, he's known to take a stroll through the Yard, inspecting the darkest corners to ensure that the facility is kept up in the highest traditions of the naval service.

The captain, naturally, has all the symbols of his authority with which he'd no more leave his house than go naked. He has his spyglass firmly tucked under his arm. In the early nineteenth century, spyglasses were expensive, and often only senior line officers would have their own. As such, they became, informally at least, synonymous with naval leadership. He's also wearing his ornate "fore and aft cap," familiar to anyone who has watched a period drama and, amazingly enough, not discontinued in the U.S. Navy until 1940. Finally, he has his sword securely belted about his waist.

So outfitted, the ghost of Thomas Tingey strides about the Navy Yard, ensuring that standards have not slipped with the advent of these newfangled gas turbine engines and fancy new Global Positioning System satellites. But perhaps the good Captain, as grand and distinguished as he may appear, is in a bit of a rush—the full panoply of naval accoutrements is belted securely over a long nightshirt.

Commodore Tingey has also taken a personal interest in the name change of the facility. In 1886, the Potomac River had silted up so much that Washington, D.C., was no longer a convenient port facility for the newer, deeper-draft steam vessels. At that point, the navy changed the name from Navy Yard to Naval Gun Foundry in light of its new role. At midnight, when the name change took place, Tingey unleashed a banshee cry that could be heard for blocks around.[55]

BURIED TREASURE

But while the Navy Yard is an excellent repository for ghosts, it pales in comparison to the Marine Barracks. Perhaps no other organization in America's history has so assiduously, and at times even jealously, guarded its history as the United States Marine Corps, and the marines of Capitol Hill are no exception.

The marines have been residents and neighbors on the Hill since President Thomas Jefferson personally selected the site in 1801 with the second Commandant of the Marine Corps, Lieutenant Colonel William Ward Burrows. The location, on the corners of 8th and I Streets SE, has become perhaps the best-known address after 1600 Pennsylvania Avenue, and comparatively few people refer to the institution by its formal name of Marine Barracks, Washington, D.C.

The Founding Fathers faced a quandary when creating Washington, D.C. Standing armies were anathema to the fledgling democracy and were relegated to a handful of coastal fortifications and to the near constant low-level conflict with Native Americans as America pushed west. Certainly Thomas Jefferson and his ilk would have been squeamish about regiments of troops in the capital. Furthermore, state militias were unreliable and owed their primary loyalty to their state and not this untested concept of a federal government.

However, the functions of government could not be left unguarded, and the marines filled the gap. Dedicated and professional, they could be trusted to handle civil disturbances without joining in them, a common problem with militias. In fact, the very origin of marines can be traced back to the days of impressed seamen in the Royal Navy. With the sailors always on the cusp of a mutiny, marines were specifically recruited to keep order.

Hence the selection of 8th and I in Washington, D.C. President Jefferson and Lieutenant Colonel Burrows selected a spot roughly between the Capitol and the Navy Yard, allowing marines to quickly respond to events at either location. And respond they did. Marines from 8th and I would crush a Know-Nothing riot in 1857, suppress John Brown at Harpers Ferry in 1859, march with the Union army at the ill-fated Battle of Bull Run in 1861 and even man machine guns to guard the Capitol Building during the 1968 riots.

But the Washington marines' fiercest action happened almost two hundred years ago. While the American army had fought above its weight class along the Niagara Frontier and out west, the mid-Atlantic region was a leadership fiasco. Lines of authority were confused, poorly trained and equipped militia units were slow turning up and little remained to stop the British when they marched toward us in August 1814.

Thanks to interservice rivalry, the only effective troops in the region, the nearly five hundred sailors and marines assigned to the Navy Yard, had been left to guard the Navy Yard bridge and to fire it in the event of a British success. Fortunately for what remained of American pride, Commodore Josiah Barney hurriedly gathered his forces and rushed them to Bladensburg, Maryland, where tough British regulars were preparing to spend a delightful afternoon sporting with the chaotic Maryland and D.C. militias.

Arriving on the cusp of battle, Barney organized his naval gunners and marines on the high ground behind the Anacostia River. They held the heights for several hours, falling back only when the supporting militia units collapsed around them. According to naval gunner and former slave Charles Ball, "If the militia regiments...could have been

brought to charge the British, in close fight, as the crossed the bridge, we should have taken the whole of them in a short time; but the militia ran like sheep chased by dogs."[56] Barney himself was severely wounded and taken prisoner on the field.

And this is where our story begins. In the pell-mell rush to defend the capital, two sergeants had been given the task of guarding the navy's payroll while their compatriots marched off. In the days before electronic accounts, and really even a reliable paper currency, that payroll would have been largely in coinage, especially silver coins.

Our sergeants had a bit of a quandary, then. Obviously, they couldn't shirk their responsibility and leave their very valuable chest to the chaos engulfing Washington. On the other hand, there was a darn good battle going on, and they were being left out. So, sensibly enough, they buried the chest somewhere on the barracks grounds and rushed off to join the troops in Bladensburg.

Fate being what it is, both sergeants fell in the action, and the U.S. government had bigger problems after the battle, what with the Capitol on fire and British officers eating dinner at the White House and all. The chest of silver coins remained lost and, compared to the cost of damage to the

World War I–era marines drilling on the Parade Deck. Legend has it that buried treasure lies underneath it somewhere, guarded by the ghosts of two 1814 marines. *Library of Congress, Prints and Photographs Division.*

city, relatively unimportant. Due to a quirk of fate, or perhaps, as the marine legend goes, out of respect for their valor at Bladensburg, the British never got around to burning the barracks. So while the money was forgotten, it wasn't destroyed.

Years later, when the story of the buried treasure became a distant memory, marine sentries began running into the two sergeants, easily identifiable from their thick leather collars since discarded from marine uniforms (and hence "Leatherneck"). The two sergeants would be seen about the Parade Deck, the area in the center of the compound where marines drill even today. They would seem to beckon to young new marines, pointing out various spots to examine. Eventually, marines would compare notes and realize that no two hiding places were the same. The marine sergeants, even in death, were cleverly protecting the payroll, even from fellow marines.

An interesting postscript to this story: in the 1930s, a marine Commandant was entertaining his granddaughters, and at some point, the two young girls heard about the tale. Late at night, they crept out of the house and proceeded to dig up the Parade Deck in search of buried treasure. No treasure was found, but they were in quite a bit of trouble the next morning!

Archibald Henderson's House

Whether the British didn't burn the barracks because they had such respect for the marines at Bladensburg, or because they simply had better things to do, is fairly unimportant. The important thing today, from the perspective of the marines' pride, is that this means that the Commandant's House, the home of the highest-ranking U.S. Marine Corps officer, is also the oldest continuously occupied government building in Washington, D.C.

Construction on the Commandant's House began in 1801, and the house continues today as the home of the current Commandant. Over the years, it has acquired a rich tradition of ghost stories, but in an ironic twist of fate, one ghost popularly attributed to it by books, websites and even early newspaper articles is unlikely to inhabit the home. Major Samuel Nichols is credited with being the first Commandant, thanks to his service in the Revolution, but it's unlikely that he would haunt a house in Washington. He died of yellow fever in Philadelphia in 1790, before plans for the city of Washington were even drawn up. It would take quite a dedicated ghost to haunt a building in a city that didn't even exist in his lifetime.

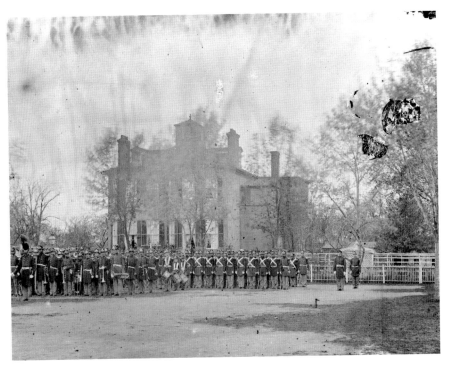

This Civil War–era photograph by Matthew Brady shows marines in front of the Commandant's House. The house is haunted by Colonel Archibald Henderson, the longest-serving marine Commandant. *Library of Congress, Prints and Photographs Division.*

Alternatively, some have suggested that the ghost is William Ward Burrows, the second Commandant who supervised the building of the house. This is possible, although Burrows never lived in the house himself. No, the ghost of the Commandant's House is almost certainly the legendary Colonel Archibald Henderson.

Archibald Henderson joined the Marine Corps before the War of 1812 and served with distinction during it. He was a marine officer aboard the USS *Constitution* as it justly earned its nickname of "Old Ironsides." After the war, then Lieutenant Colonel Henderson was appointed Commandant, whereupon his battles involved less enemy fire and more political infighting. He went head to head with President Jackson, no slouch in the tough old curmudgeon department himself, over a proposal to fold the Marine Corps into the army as a cost-saving measure. Not only did he deflect this, but the size of the Corps was also increased and Henderson walked away with a promotion to colonel.[57]

In another famous anecdote, he reportedly tacked a note to the door of the house during the 1837 Seminole War: "Gone to fight the Indians. Will be back when the war is over. A. Henderson, Col. Comdt." Whatever the truth of it, Henderson was brevetted (an honorary promotion) to brigadier general for his service in that war. After that, in 1857, a group of Know-Nothing thugs had managed to "borrow" a cannon in its riotous attempt to sway a municipal election. President Buchanan called out the marines to restore order, and Henderson personally stepped in front of the cannon muzzle, daring the rioters to fire and distracting them while the marines formed a firing line. Six of the rioters were subsequently killed. No marines were harmed.

Known as the "Grand Old Man of the Marine Corps," Henderson died in 1859 after fifty-three years of service, thirty-eight of them as Commandant. Amazingly enough considering his life, he passed away quietly on a sofa in the house during a pre-dinner nap. The sofa is still there, and marines will happily show it to visitors when the house is periodically opened to the public. Like Commodore Tingey, Colonel Henderson was reputed to have willed the house to his heirs, but its similarly apocryphal.

This is not to say that Henderson himself didn't stick around. Colonel Henderson is occasionally seen at rest on his favorite sofa or, more commonly, still working in his study. A vivid account was described in a 1923 article. In this case, Henderson was seen by Mrs. George Barnett, a wife of a retired marine major. Mrs. Barnett seems to have had a particular problem with ghosts, as she was driven from a Georgetown residence by "queer noises," "ghostly steps" and an apparition of "a woman dressed in a costume of a forgotten period."

Naturally, marines take care of their own, and Mrs. Barnett was invited to stay at the Commandant's House, where unfortunately her luck was little better. In contrast to today, when electric lighting and new windows make the house almost cheerful on the inside, Mrs. Barnett felt it was eerie. The rooms were somber, even during the day, and "the portraits of former Commandants of the past gaze down from the high walls." Shortly after she moved in, she was woken in the early hours of the morning by a marine in the full-dress uniform of an earlier period. After she awoke, the figure vanished and the house was searched. Naturally, nothing was found, although the figure would be seen from time to time, along with the "measured tread of a man in deep thought, and the rustle of invisible papers."[58]

Archibald Henderson did not feel the need to remain silent about changes in his beloved Corps. During World War II, the Marine Corps—and therefore the seventeenth Commandant, Major General Thomas Holcomb—faced

a problem. During his tenure, the Corps would expand from about 16,000 marines to about 300,000, and finding that many men, much less training and keep the marines' traditionally high standards up, occupied a great deal of General Holcomb's time and attention. Although he quietly resisted it, he was overruled by the Secretary of the Navy and President Roosevelt and women were authorized to join the Marine Corps in late 1942.

Naturally, this decision, as weighty as it was, was not the only thing to occupy the Commandant's attention. The general's son, Franklin Holcomb, had graduated from the School of Foreign Service at Georgetown University recently and was eager to serve his country. Unfortunately, he had mangled his knee in a car accident and under normal circumstances would have been ineligible for service in the Marine Corps. But he kind of knew a guy, and with a stack of letters of recommendations in hand, he managed to be commissioned a second lieutenant. In short time, he found himself in North Africa as an intelligence officer, working (often behind enemy lines) to collect intelligence for the upcoming invasion.[59]

While he was back stateside, though, he was invited to dinner with his father, along with his senior officer, Colonel William A. Eddy. This was right on the cusp of the decision to allow women to serve, and Lieutenant Holcomb must have been curious about the inside scoop, considering that he had been overseas for some time. Going right to the source, he asked his father, "General Holcomb, what do you think about having women in the Marine Corps?"

At that very moment, the painting of Archibald Henderson that hung (and still hangs) above the buffet table fell onto the table with a clattering racket. Clearly, Henderson did not warm to the idea.

We shouldn't leave without noting one final tidbit about General Holcomb. While he was clearly opposed to the idea of women serving, once the decision was made, he professionally carried out his orders. Unlike the other services, he allowed no catchy nicknames, remarking in a 1944 issue of *Life* magazine, "They are Marines. They don't have a nickname and they don't need one."[60]

THE RED RUBBER BALL

While the 8th and I is normally thought of as the plot bounded by 8th, 9th, I and G Streets NE, the Marine Barracks has expanded across I Street and,

even more recently, south of the freeway. Today, roughly 1,200 marines work at the barracks; when the Marine Corps was reconstituted in 1798, the authorizing act called for a total force of 500 marines. Living standards have improved since then as well. The days of enlisted marines living in open halls are long over, and the new barracks in many ways resemble college dorms more than traditional military accommodations. Clean and well-maintained college dorm rooms, that is, if that's not an oxymoron.

But in the newer building wedged between I Street and the SE-SW Freeway, there is an underground parking garage. Like all access points to the barracks, it's guarded by an armed marine and is the site of one of the more disturbing ghosts in the barracks—or, for that matter, on Capitol Hill.

The stories always start the same. A marine recently assigned to the barracks, or perhaps a visitor, parks his car on the lower level and sees a red rubber ball—the kind school kids and hipsters play kickball with—bounce down the ramp. Bemused, he looks for the ball so that the child who dropped it isn't disappointed. After a bit, he's forced to conclude that the ball has rolled into some out-of-the-way nook and gives up the search.

When he arrives at the street level, there is no crying child, just the marine on guard duty. He brings the matter to his attention and is greeted with a

Feel free to ask the marine sentry about the mysterious red rubber ball that has been seen bouncing down this ramp. *Photo by Maria Helena Carey.*

rueful shake of the head. "Sir," the sentry says, "I'm afraid there is no child. That's been happening ever since the building opened." Apparently, shortly after the parking garage opened, a small child was hit by a car emerging from it. Ever since, the red rubber ball is seen bouncing down the ramp. No ball is ever found.

NEAR NORTHEAST

URBAN RENEWAL? THESE GHOSTS NEVER LEFT

Capitol Hill has a distinct divide along East Capitol Street, and the area north of it grew in a quite different way. While there were houses in the fringe around the Capitol, and eventually along East Capitol and Lincoln Park, northeast Capitol Hill (often referred to as Near Northeast) was really developed along H Street NE.

H Street was sparsely settled through the Civil War and even the years following. Like many outlying areas, it was a mix of cemeteries, farms, coal and timber yards for the nearby B&O Railroad and other unpleasant activities. It was anchored on the western end by the Swampoodle neighborhood, an Irish neighborhood known as quite a rough-and-tumble area.

We can presume that for a neighborhood known for its murders, with a healthy dose of blarney thrown in, Swampoodle was well haunted, but it was almost thoroughly destroyed to build Union Station in the early 1900s, and neither houses nor ghosts remain from that era. Really, all that remains is Gonzaga College High School, a Jesuit school still in operation.

But the death of Swampoodle meant good things for H Street NE. A streetcar line was completed in 1871, connecting H Street all the way to the White House. Workers downtown could now reliably purchase a new home in northeast D.C. and commute to work.

Some of these folk were Irish residents of Swampoodle who had moved up the social ladder and could now afford real brick houses. Others were African Americans, often collectively purchasing entire blocks as a group to avoid restrictive real estate practices of the time. And still more were

German, Greek, Italian or other immigrants who saw a newly constructed house as the attainment of the American dream.

While hardly a racial utopia, H Street and the surrounding streets were far more mixed than the older Washington neighborhoods. White and black people still tended to cluster together, attending their own churches, theaters and, of course, segregated schools, but they lived in similar houses with no real physical separation between them.

Gradually, the development along H Street merged with the growth of Capitol Hill to the south, to the point that there is no tangible dividing line between the two today.

THE GAS LAMP SUICIDE

Our first story begins with a young bookbinder who moved to Washington, D.C., from Connecticut in the early 1880s and settled in one of the row houses on the north side of the 600 block of G Street NE. At the time, it faced Ludlow Elementary School; now it's the ball field of Ludlow-Taylor Elementary. Lewis Terry and his wife, Alice, were not quite the vanguard of development in the neighborhood, but not far behind. Shortly after they moved in, they had a son, Alfred, who would grow up in the house and know it as home.

Years later, in a 1935 *Washington Post* article, Alfred would recall an episode when he was still a small boy. The family was sitting on the front stoop when his father stepped inside for something. This predates the days of common use of electricity, and the house was lit by gas. His father entered the dining room, struck a match to light a lamp and uttered a startled exclamation. There on the sofa lay a woman, her long hair spilling over the headrest. She was pale as well—a corpse, without question. Lewis Terry turned the light to full flame to get a better look, but the lady disappeared in the full glow of the gas lamp. As the light was dimmed, she would reappear, and perhaps even more ominously, the smell of gas fumes would fill the air.

Naturally, the Terrys were intrigued by this strange vision and made inquiries of their neighbors. It turned out that in this very house some years before, a young lady fitting that description (although presumably less pale) had committed suicide, to the shock and sadness of the neighbors. It came as no real surprise to the Terrys to learn that she had lain down in that very spot, turned the gas up and went to sleep forever in the fumes.[61]

The episode made a profound impression on young Alfred Terry, an impression he would never lose. He grew to be a devout Spiritualist, an adherent of a religious movement that flourished from roughly the 1840s to the 1920s. Mary Todd Lincoln was perhaps the most famous follower in Washington, seeking to connect with her dead son, Willie, but she was hardly alone. Spiritualists believed not only that a soul continues to exist after death but also that it could stay in communication with the living, particularly through the assistance of mediums, or people particularly attuned to the "spirit world." While numerous mediums would prove to be out-and-out charlatans, Spiritualism as a faith was firmly believed in by many.

One of those was Alfred Terry. He moved with his family to a new house at 131 C Street NE when he was a teenager, but the dead lady on the sofa stayed with him. He became the pastor of the First Spiritualist Church, which met at 1012 9th Street NW, and even gained a brief degree of notoriety when he publicly dueled with the son of Sir Alfred Conan Doyle, author of the Sherlock Holmes stories and an "ardent defender of mediumship and a firm believer in spiritualism."[62] Sir Alfred's son, Denis, inherited some of that belief, and in a series of dueling letters to the editors in the *Washington Post* in the 1940s, the two argued publicly about the nature of mediumship versus seership and other technical matters within the Spiritualist faith. (Doyle didn't even believe in calling it that, by the way.) They did manage to find common ground on the statement that "the religion of spiritualism has nothing to do with ghosts or clanking chains, but with the return and manifestation of the so-called dead, who come to comfort, enlighten, and inspire their loved ones on earth."[63]

Whatever the technicalities, Spiritualism was on the wane in Washington and elsewhere by this time. Soon, the Terrys' house on C Street, where he heard spirits walk the stairs and doors mysteriously open and close, as well as the church building on 9th Street, where "voices frequently come out of the air during the meetings," were both bulldozed, doomed to spend eternity as parking lots, because that's what Washington built after World War II. But the house on G Street still stands, overlooking little-league tryouts and school kids playing.[64]

SILVER BULLET SEDGWICK

It's common nowadays to look back at the Jim Crow era and just see a divided America. Though segregation was very real in Washington, D.C., it had a very different flavor. There were few, if any, "Colored Only" signs at bathrooms and drinking fountains; it was simply understood that some were off-limits. Cultural barriers, more so than legal ones, kept people apart. Near Northeast, like many working class neighborhoods, was home to blacks and whites, living side by side at times, but in very different worlds.

As such, the Metropolitan Police Department had black officers as early as 1869. While partially done as a result of African Americans being elected to the Common Council in the wake of the Civil War, this was also done because it was found, not surprisingly, that African Americans reacted significantly better to African American police officers in their neighborhoods.

So, here in Near Northeast, we have black officers serving alongside white officers. And in the late summer of 1895, one of them, Patrolman Sedgwick, began noticing something odd on his beat. Sedgwick was

The Ninth Precinct. *Photo by author.*

assigned to the Ninth Precinct, an area bounded by East Capitol, 1st Street NE and Boundary Avenue NE (now Florida Avenue). As he put it in his official statement:

> *It was at Tenth and D streets northeast, and was just five minutes after 12 o'clock. I heard a shuffling, and thought it was my relieving officer coming. I thought I would play a little joke on my partner, so I stepped around the corner and picked up a cobble stone to shy at him, and was just going to throw it when I saw that the thing was dressed in white and had no head. I dropped the stone, and as I did so there was a gust of wind and an awful groan, and the ghost fell against the fence, knocking down three panels. I looked and the ghost was gone, but there were the three boards to prove that it had been there.*[65]

Patrolman Sedgwick would continue to see the apparition in the area just north of Lincoln Park. The ghost would appear, say nothing and then disappear. Finally, frustrated at the ghost's apparent unwillingness to cooperate, Sedgwick called on it to stop, and after its failure to do so, he pulled his revolver and shot at it, to no effect.

Officer Sedgwick and Officer Gee of MPD then reported seeing it at 11th and C Street NE and, a few days later, at 9th and Maryland Avenue NE. The latter location was particularly significant because it was half a block away from the Ninth Precinct Police Station.

Sure enough, Station Keeper Burkhart of the Ninth Precinct also reported that the "apparition seemed to be a man robed in white, without a head, and with short arms. It was leaning against a tree box and moaning in a most unearthly manner." This information was of particular importance, as Station Keeper Burkhart was, as the *Washington Post* put it, "a most reliable man, and not in the least given to romance."[66]

This was presumably noted because Patrolman Sedgwick was, as the *Post* put it, "a colored man, and, of course, rather susceptible of visits from those not of earth." Other than the de rigueur patronizing racism of the time, the *Post* portrayed Sedgwick as a fairly respectable witness, noting that he "has a splendid record for courage and bravery." It was certainly helpful that he was backed up by two white officers, especially the reliable, nonromantic station keeper Burkhart.

Patrolman Sedgwick was a man with a plan, however, and despite his initial failure to apprehend the headless ghost the first time, he resolved to try again properly armed. As he noted, "[T]here's just one way to kill the

ghost, and that is with silver bullets. I am going to have some made and get another shot at that ghost. I am not going to spend much money, but I will have those silver bullets."

The series of incidents made great copy, and reporters clearly had quite a bit of fun at Sedgwick's expense. In fact, poor Sedgwick would go on to be railroaded on a charge of drinking on the job the next year, trumped up by white officers. The press reports from that episode consistently referred to him as "Silver Bullet Sedgwick." But at the time, the *Post* was not as sanguine, and it ended its article with a sensible warning: "With all this evidence it must be agreed that something if flitting about the streets of the Northeast. If it is human it is taking great chances in flirting with the armed police, and especially with Sedgwick and his silver bullets."[67]

H(AUNTED) STREET PLAYHOUSE

The neighborhoods surrounding H Street would be stressed by more than ghosts, and the solutions would require far more than silver bullets in the next century. Near Northeast continued on through World War II as a comfortable working-class residential neighborhood with corner stores, a plethora of neighborhood schools and churches, and a thriving commercial corridor along H Street NE. Notable among them, the Atlas Theater, a one-thousand-seat movie theater that opened in 1938, would serve only whites, while a few doors down, the Plymouth Theater, converted from an automobile showroom during World War II, served black residents.

After the war, two things would spark the decline of H Street: suburbanization and, bizarrely enough, the civil rights movement. With millions of returning GIs fleeing the cities for the suburbs in the 1950s, a phenomenon often oversimplified as "white flight," inner-city shopping corridors like H Street struggled to survive. And when the civil rights movement slowly removed barriers to African Americans, many black residents began shopping in the newly accessible downtown department stores. Often blamed for H Street's downfall, the 1968 riots in the wake of Dr. Martin Luther King's assassination punctuated rather than precipitated it.

This is not to say that H Street simply folded up and quit. People continued to live in the neighborhood, if perhaps with more boarded-up shops than anyone would have preferred to see. Struggles came and went, but in the

Mischievous happenings occur regularly at the H Street Playhouse. Are they the antics of a three-year-old boy tragically burned to death across the street? *Photo by Maria Helena Carey.*

last decade there has been renewed vitality in the corridor, with bars and restaurants opening almost monthly.

One of the first trendsetters of the H Street resurgence was the opening of the H Street Playhouse in 2001 in the old Plymouth Theater building. Having been a movie theater and an auto showroom (as well as a roller rink, restaurant, print shop and furniture supply store), the space began a new life as a live theater venue under the leadership of founders Adele and Bruce Robey.

Now, theaters and ghosts (much like cops and ghosts) have a long and symbiotic relationship. There are any number of superstitions believed by theater folk, and H Street Playhouse is no exception. Like many theaters, the Playhouse keeps a ghost lamp lit, a nod to the somewhat contradictory beliefs that the light keeps ghosts away and/or lighting the stage allows ghosts to rehearse. And of course, like many theaters, H Street has a resident ghost.

Bruce passed away a few years ago, but Adele shared a few stories of unexplained happenings at the Playhouse. Items often go missing, costumes in particular. Now it's not impossible, and probably even likely in many cases, that these may be simple cases of pilfering by other more, um, worldly sources, but Adele recalls a brown T-shirt, a costume required for a particular show, disappearing. It had been on the rack, ready for the show, when the staff went to handle other details. No one could have gotten into the space, and the back gate was locked (and noticeably loud if opened). Just before the show, it vanished from the rack, never to be seen again.

While our mischievous spirit has an affinity for costumes, it doesn't limit its portfolio. On another occasion, members of the Theater Alliance, the theater-in-residence at H Street Playhouse, were holding a meeting on the site. At some point, one of them went into the back office and found that the modem router was gone. There was no other way into the office other than the area where they had been holding the meeting; the router was in the natural habitat of routers, stuffed in a back corner and difficult to get to. Plenty of easier-to-grab items were in plain view, if someone had been able to get in. They had used the system just half an hour before, when the meeting had started, and the router never turned up again.

But the most curious story sounds oddly familiar to readers of this book, if not to Adele Robey, who had not heard of the previous tales of Peter Waldon's money and the Library of Congress. In the spring of 2005, H Street Playhouse presented a production of the musical *Spitfire Grill*. Naturally, as a good portion of the play takes place in a diner—and, in fact, an onstage

raffle occurs—very realistic fake prop money was required. Adele was stage-managing the production and found when she was setting up props that the money had disappeared from the bag. Everyone frantically searched for the props, and finally, in desperation, Adele and others threw in real money from their wallets. The show, of course, must go on, and the musical continued. Amazingly enough, as the show came to the point where the money was required, the prop money reappeared in the bag.

Could it be Bruce Robey playing these tricks? Bruce was a legendary figure on Capitol Hill whose death of a heart attack in 2009 left Capitol Hill reeling. Obviously, that would be fairly difficult, as he was alive for much of it. But that's not to say that his presence isn't still there. According to Adele, she has a feeling that "since my husband died, since he really built this place from scratch, that he's here sometimes, but I get more of the sense that he's just keeping an eye on things."[68]

Perhaps the ghost, then, mischievous as it is, is the spirit of poor Leroy Herbert. On a cool October day in 1905, Leroy's mother left the three-year-old in his room in a house directly across the street, 1366 H Street NE, while she went downstairs to make lunch. Tragically, the curious Leroy managed to get ahold of some matches and lit his clothes on fire. His mother heard the screams and ran upstairs to find "the little fellow lying on the floor, his clothes a mass of flames." A passing police officer called the nearest hospital for its ambulance, but it was not available, so they bundled the boy into the Ninth Precinct's police wagon and took him to Eastern Dispensary and Casualty Hospital on the 700 block of Massachusetts Avenue NE. Dr. Baldwin, the head physician, mistakenly believed that it was a "rule of our institution not to care for children patients beyond the regular emergency treatment" and sent him some forty blocks away to Children's Hospital, where he passed away shortly after midnight.[69]

Leroy's burns were so bad that it is unlikely he would have survived anyway, but the four-mile journey in a vehicle with no heat, especially considering the state of roads and suspensions in 1905, did him little good, and his parents were understandably upset that the poor child was put through so much unnecessary suffering. Maybe Leroy is still upset at his treatment, but perhaps it's best to think that he's perpetually a three-year-old boy, curious about the world around him and delighted to pull one over on the grownups.[70]

The Brent Vault Vampire

For all the ebb and flow of life on H Street, there is one institution nearby that has stood above it all, predating not just the resurgence of H Street but also its very development as a neighborhood.

Just to the north, across Florida Avenue, lies the picturesque campus of Gallaudet University. It was the nation's very first college for deaf students and remains the only one where all programs are designed for deaf students. Florida Avenue was, in fact, a boundary delineating the city of Washington from the District of Columbia and called, fittingly enough, Boundary Avenue. It wouldn't be until the formal combination of the two in 1871, and the growth of the city, that Boundary would be renamed Florida in 1891.

Among the farms and estates in the area, two occupy our attention here. The first is Kendall Green, the country retreat of Amos Kendall. Kendall is largely forgotten today, but he was a major player in the Washington political scene of Presidents Jackson and Van Buren, so much so that John Quincy Adams once remarked that Jackson and Van Buren's administrations had been "for twelve years the tool of Amos Kendall, the ruling mind of their dominion."[71]

Whatever his machinations on the political stage, Kendall had a humanitarian side as well. He had made a decent fortune managing the business side of Samuel F.B. Morse's telegraph operations and was hit up for funds by a group of gentlemen for a school for the blind and deaf. Having done so, it soon came to their attention that the administrator was unfit to run the school, and the entire enterprise was in danger of foundering. Kendall donated several acres of Kendall Green to the school, and shortly after, in 1857, the Columbian Institution for the Deaf, Dumb and Blind was chartered.

Kendall brought in a young educator, Edward Miner Gallaudet, to helm the new school. Gallaudet's father, Thomas Hopkins Gallaudet, had pioneered the education of the deaf, and eventually the school would be named for him. Upon Kendall's death in 1869, the school purchased the rest of his estate, and the oldest portion of the campus is roughly the location of Kendall Green.

Just a short walk down Boundary Avenue stood another older and somewhat grander estate. In 1817, the first mayor of Washington, Robert Brent, began construction of a stately, two-story Greek Revival mansion. Unfortunately, he died in 1819 shortly before it was completed. However, he did manage to complete construction of an elaborate

Gallaudet University just before the turn of the century. *Library of Congress, Prints and Photographs Division.*

Egyptian Revival mausoleum on the site, which was fortunate as it gave his heirs somewhere to put him.

His daughter, Eleanor, and her husband, North Carolina congressman Joseph Pearson, completed the house, which combined rural gentility with sweeping views of the Federal City. Eventually, their only daughter, Elizabeth, married a naval officer by the name of Carlile Patterson, and the house was informally known as the Patterson House to the neighbors. After the Civil War, Patterson became head of the U.S. Coast Survey and was a personal friend of President Grant's. For some time, the Patterson House was a hub of Washington social life, particularly for those looking for a country retreat from the hustle of the city.

But the Patterson family's interests drifted elsewhere, and the house began a slow, graceful decline. The family sold off chunks of land, to Gallaudet along Florida Avenue and to the B&O Railroad to the west, and the Patterson House grew deeper and deeper into neglect. By the early 1900s, the house was all but abandoned, with the only surviving descendant of the family living in Europe and the estate managed by a trusteeship and under the direct control of only one elderly caretaker, Cephas Johnson.

In the summer of 1915, Mr. Johnson notified police that the house had been plundered, a curious event in that the house was empty. Nor was it a casual break-in. The intruders had taken the time to systematically search the house, breaking down walls looking for hidden panels, splitting open trunks kept in the attic and even attempting to remove two very large, built-in mantelpieces.[72]

Whatever these very deliberate robbers were looking for must not have been found because six weeks later, Cephas Johnson again heard a prowler one Saturday night. The next morning, he discovered a large crack in the side of the vault. All ten caskets inside had been torn from their niches and pried open. The remains formed "a gruesome pyramid. Pieces of bone, a few shreds of cloth, and a quantity of dust were scattered about, telling of the manner in which the ghouls had delved among the dead bodies."[73]

The remains were gathered as best they could, and the bodies of Robert Brent, wife Catherine, daughter Elizabeth Pearson and three others were interred in a family plot in Maryland. Hundreds of people turned out to examine the broken vault, and it was quite the talk of the city for a few days. No one was ever caught, and speculation ranged that the thieves were after some sort of lost treasure, perhaps a mysterious amount of gold supposed to have been hidden on the estate during the Civil War.[74]

The mausoleum stood empty, the bashed-in side wall never repaired. The house itself suffered a disastrous fire just after Christmas and was left a blackened hulk. World War I saw the property turned into an army base, Camp Meigs, and after that, a local salvage and hardware magnate, Sidney Hechinger, purchased the property and opened one of his first stores there—fitting, as the original use of the property by Robert Brent had been as a woodlot.

As the last remnants of the estate were swept away in the 1920s, the area around the vault still filled the neighbors with unease. Residents of the neighborhood of Ivy City to the north had to cut through the area to get to the H Street area and Near Northeast, and many would walk almost a mile out of the way to avoid it. Deserted mansions and broken-open crypts are scary enough in the best of times, but long-term residents felt that there was something more afoot, something that couldn't be explained by well-prepared burglars ransacking fifty-year-old graves for dubious stories of lost gold.

Then, in 1923, a young writer for the *Washington Post*, Gorman Hendricks, gathered some of these tales and put them in writing. The vault was by now almost completely overgrown, and the "door of the vault now hangs on

rusty hinges, and the epitaphs on the marble slabs…have long since been obliterated by the hand of time."

As the local story went, more than seventy years before, the thick wooded area behind the mansion was once the haunt of none other than a vampire. Things were first noticed when a young girl died and was laid to rest in the mausoleum. A few days later, a passing woodcutter returning home late in the evening saw a white-robed woman emerge from the vault and disappear into the woods. The Pattersons and other residents of the house were above such things and paid no attention to the stories—or at least the white residents of the house did. The slaves, on the other hand, took the rumors quite seriously and regarded the woods behind the house with trepidation.

Their fear was validated when a groom failed to appear the next day. A search of the grounds found his body, with the telltale imprint of two teeth marks on his neck. The slaves, no doubt resisting the urge to tell their owners, "We told you so," informed the family that this was the work of the undead. A watch was maintained on the vault, and things remained quiet for several days. Then, "on the eve of St. George [April 23], while a storm was brewing and the flashes of lightning played over the somber structure, the rusty door again creaked, and a figure crept stealthily out and glided through the woods in the direction of the mansion." Naturally, those watching froze in horror at the sight of the young girl whom they had recently buried heading toward the house. Using a different route, they raced her back to the house, locked the doors and warned the other inhabitants.

The next day, one of the men of the house, "more intrepid than the rest," visited the grave to see what was amiss. The stone slab had been moved (it was estimated to weigh three thousand pounds in 1915), and the flowers left on the site were in disarray. What's more, upon opening the grave,

within the box, so the legend goes, lay the body of a girl. The cheeks were rosy and the lips a bright red. But horror struck the watchers when they discovered the front teeth were as long and sharp as the teeth of a wolf. The expression on the lips was one that caused the man to quickly fasten on the lid of the coffin and leave the place of death.

The vault was again sealed, and the story faded into myth. Years later, a visitor came to the house "with blanched cheeks" just about dusk, on the eve of a brewing storm, and a strikingly similar tale:

This time, instead of gliding off it [the same figure] turned and gazing in his direction gave a terrible laugh. As the figure passed him, the man said that he caught the foul order of the charnel house and saw the gleam of hell fire in the eyes of the thing that came forth from the dead to the eerie sound as of whispering from the dead, holding communion within the tomb. Within a week after seeing the apparition the man died.[75]

This was shortly before the Pattersons moved out, and the house began its decline. Abandonment did little to quell the fears of the locals. Perhaps the house and vault were broken into to find some gold left behind. Or perhaps there was another motive: to quiet an undead spirit and solve a neighborhood nuisance once and for all. Either way, the removal of the remains in 1915 ended the stories of vampires just north of Capitol Hill.

What became of the vault? The site was some distance from the house and was part of the land sold to Gallaudet University. As best as can be determined, it's now the site of Ballard North Hall, once named Cogswell Hall. Cogswell Hall has had stories flying about it for decades. Many of the more recent ones trace their origins to a pair of tragic murders in 2000–2001, when a student, Joseph Mesa Jr., for reasons that remain murky, killed two of his fellow students. Today, many of the stories attribute the odd happenings to the ghosts of these two, but that's fairly unlikely, as similar stories predate this tragedy.

So what does happen in Ballard North? It seems to be centered on one particular dorm room on the first floor, room 105. Students in the room report curious pockets of unusually warm and cold air, often both at the same time, with no windows or air conditioning in operation. Alarm clocks mysteriously change the time they're set for, in no coherent pattern. Lamps remain lit when turned off or even unplugged. Is room 105 the exact site of the Brent family vault?

GHOSTS OF GALLAUDET

The ghosts of Gallaudet are not limited to Ballard North. Like any historic school, it has its share of the "four girls said Bloody Mary" type of tales, as well as statues that move at exactly midnight. In this particular case, the head of the statue of Edward Miner Gallaudet will turn into a skull at the stroke of twelve o'clock. And in a quirky tradition unique to Gallaudet, there is the coffin door.

Legend has it that any freshman passing through the coffin door at Gallaudet University will fail to graduate. *Photo by Maria Helena Carey.*

Now, "coffin doors" were fairly common in nineteenth-century America; they were second exterior doors to allow coffins to be brought in and out of the house. Funeral preparations were held on site, and it was often considered bad luck for the dead to leave by the front door. Alternatively, and sometimes contradictorily, coffin doors are also any door wide enough to handle a coffin and pallbearers, including the front door.

But Gallaudet's coffin door is something else. It is an exterior door on College Hall, a stunning High Victorian building known for its vaulted ceilings and stained-glass windows. The door gets its name from its shape, which is best described as, well, a coffin. It's a quaint architectural oddity, but students (and not a few faculty) swear that any freshman who exits through it will not graduate. The legend dates back to the time of President Grant, who, like many presidents, visited the school. As he pulled up in his carriage, a group of rowdy freshmen exited by the door, embarrassing the school. Supposedly, they were summarily dismissed, giving birth to the legend.

Additionally, The president's residence was built in 1869 and has housed all ten of Gallaudet's presidents. It is named after the first one, Edward Miner Gallaudet, and known around campus as the "EMG Residence" or, simply, "House One." The building has at times housed professors and even, on the third floor, the first female students when Gallaudet started accepting women in 1887.

Naturally, such an old and distinguished house is well haunted. Former president I. King Jordan, known around campus as IKJ, recalled an occurrence when his wife, Linda, was awakened by a strange noise shortly after they moved in, perhaps a shutter rattling on a windless night. Waking her husband, they investigated and found nothing. IKJ went back to sleep, and a short while later, the house alarm went off. Waking her husband, Linda and IKJ again searched the house with no result. The alarm went off a second time, and for a third time the Jordans inspected the house, this time assisted by the campus police. After this episode, both IKJ and his wife reported strange happenings and a feeling that others were sharing their house, but nothing as dramatic as this first night.

The Jordans were also not superstitious types. "Before this happened, neither Linda nor I believed in ghosts. We thought the idea was silly. But now both of us are not so sure." So what, or who, was in House One?[76]

IKJ believes that it is the presence of Sophia Folwer Gallaudet, the devout mother of EMG, still keeping an eye on the place. But Linda has another theory. I. King Jordan took office as the first deaf president of Gallaudet in

House One, as the president's house is known, contains many haunted stories, including one of a rocking chair that moves on its own. *Library of Congress, Prints and Photographs Division.*

1988 after a series of protests, collectively called the Deaf President Now movement, demanded that the next president be deaf. Linda Jordan, who can hear, thinks that perhaps the ghost is Edward Miner Gallaudet himself, making a loud, noisy racket that would only wake a hearing person. EMG was also ready for a deaf president and wanted to be absolutely certain that Gallaudet got one, it would seem.[77]

PART VI

BEER, BONES AND CEMETERIES

GHOSTS OF HILL EAST

World War I saw a drastic expansion of Washington, D.C., the Navy Yard in particular, and with it came a renewed demand for housing on the Hill. Rising living standards meant that cramped and often poorly constructed housing around the Navy Yard was increasingly less desirable, even when it wasn't haunted, and new streetcar lines and the popularization of the automobile meant that you could now move a little farther afield.

Capitol Hill marched steadily toward the east, toward the Anacostia River. This area had been empty, with streets laid out but only a scattering of houses built. It was, in many ways, a desolate area with only a ramshackle house here or there, used for industrial and other unpleasant uses.

THE HAUNTED BREWERY

In 1891, a German immigrant by the name of Albert Carry took advantage of the cheaper land costs by opening his new brewery on the block bounded by 13th, 14th, D and E Streets SE, grabbing a choice spot before housing was built there. The site had previously been occupied by a much smaller operation, the Navy Yard Brewery. We can only assume the name referred more to the clientele than the location, which is a healthy stumble to the Navy Yard proper. The new brewery was a behemoth of an operation, one of the largest breweries in town, and it boasted a beer

An 1839 watercolor of the Anacostia, or as it was known then, the Eastern Branch of Potomac River. Capitol Hill would not extend this far until after World War I. *Watercolor by August Köllner, Library of Congress, Prints and Photographs Division.*

garden that could seat one thousand people, with multiple 240-barrel vats in operation at various times.

Events in 1912 brought a great deal of unwanted drama to the brewery. Questions remain to this day, but the story centers on two men: Arthur Webster, who worked days at the Navy Yard and nights as an auto mechanic at a shop on the corner of 11th and A Streets NE, and Lentie (also Lentte or Lennte) L. Jett, a fireman at the brewery. It probably should be noted that a "fireman" in this context is someone who makes and tends fires rather than puts them out.

That spring, the two men got into a public fight in front of the brewery. Webster punched Jett in the nose, knocking him down. Jett grabbed a milk bottle, got up and defended himself until bystanders intervened. By all accounts, they made up, but relations remained uneasy between the two of them.

Then came the night of Monday, September 17. Webster came home at about midnight and had a bite to eat. He told his wife that he was going to pop over to the brewery for a few before bed, and his wife, shockingly,

thought that this was a bad idea. Nevertheless, Webster insisted and managed to convince his wife that he would be back shortly. Mrs. Webster, no doubt familiar with this thread of conversation, didn't wait up.

Webster met Jett and another worker, Michael Barrett, in the boiler room, and they proceeded to drink a bit. According to Barrett, Webster had been drinking already and, in due course, took Jett behind the no. 6 boiler. They got into a bit of an argument, and Webster was overheard threatening Jett. At 4:30 a.m., Barrett left, noticing that Webster was still behind the no. 6 boiler.[78]

Mrs. Webster went down to the Fifth Precinct Station and initially received very little help. It appears that the police were familiar with Arthur Webster and had formed a bit of an opinion as to his whereabouts. But eventually, when he failed to turn up, they began tracking him down. They asked Jett quite a few questions, so much that he fell apart, went home and shot himself. The mystery was (probably) finally solved when traces of bones and teeth were raked out of the brewery's ash pit a few days later. Despite

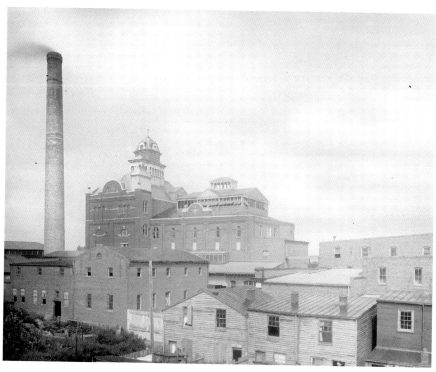

A brutal murder at the National Capitol Brewery in 1912 gave rise to stories of mysterious smells and smoke. *National Photo Company, Library of Congress, Prints and Photographs Division.*

Mr. Webster's father's insistence that others were involved, the inquiry held that Jett had in all probability killed Webster and stuffed him into the boiler.

National Capitol Brewery survived the sad and tragic incident unscathed and continued operation until it was shut down by prohibition. For several years, the site produced ice and ice cream, and eventually it was torn down to build a Safeway, which stands there today.

For years after, even when the brewery was a distant memory, neighbors in the area would say that they could smell the strong and distinct odor of a brewery in operation and even, when the moon is right, still see the smoke rising from unlit boilers. Is it the ghost of Arthur Webster, still having a late-night drink in the boiler room? Or Lentie Jett, heart heavy with a guilty conscience, pushing Webster into the furnace?

GHOSTS OF THE LAST MILE

As Capitol Hill developed, it ran into a fringe of government buildings that no one wanted in their backyard. Its name, such as it is, is Reservation 13, which dates back to the founding of the city when planned parcels were numbered (Reservation 1 is now the White House). Over the years, it has housed a workhouse for the poor, a public hospital, a morgue, a crematorium, a potter's field, a trash yard and other hard-to-place civic facilities. But perhaps the most imposing of all of them was the old District Jail.

The D.C. Jail is still located on Reservation 13 today but in a new building that, while not cheerful by any stretch, has none of the Gothic horror of the old building. The old jail stood a bit north of the current one, on the corner of Independence and 19th Street SE, and it was exactly what you pictured a Victorian-era jail to be: grim, dark and looming.

The District's previous jail, the "Blue Jug" at Judiciary Square (so named for the bluish stucco that covered it), was woefully overcrowded and dilapidated, so after much debate, a new one was built on the outskirts of the city. The first prisoners were transferred in 1875, and within a decade or two, even this new, larger facility was overcrowded. In 1908, President Theodore Roosevelt appointed a commission to investigate conditions at the jail, and as a result, the Lorton Workhouse and Reformatory was built in Occoquan, Virginia, to handle prisoners. The jail remained for people awaiting trial and those with sentences under a year.

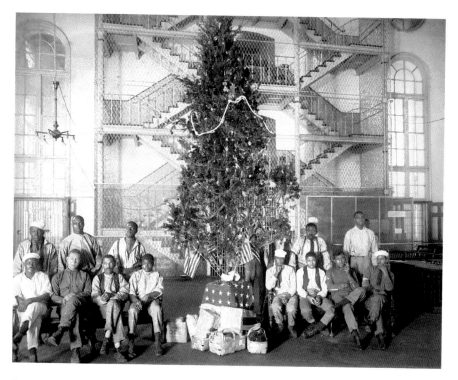

This 1919 image shows inmates preparing for Christmas. *National Photo Company, Library of Congress, Prints and Photographs Division.*

It also housed an even darker side. For more than eighty years, the District Jail was Washington's execution grounds. At first, they were done by hanging and carried out by the ironically likable "Colonel" Robert Strong. Strong had got his start on a whaling ship, came to Washington, D.C., to work on the construction of the new House wing of the Capitol and ended up as an officer at the jail. His background as a sailor gave him a familiarity with ropes and knots, and he became the go-to guy when you needed someone hanged in the District. He was known for his cheerful manner and would send the condemned off with a final bit of advice: "Now my dear fellow, if you don't cheer up you'll never learn to look on the bright side of life." No doubt they had a good chuckle.[79]

He brought his now practiced skills with him over to the new jail, and on April 2, 1880, they executed James Madison Wyat Stone, a man who murdered his wife. Unfortunately, the condemned man "weighed probably about 200 pounds, his neck was short, and having been in jail over two years,

his muscles, of course, had got very soft from want of use and exercise." Strong placed the noose and sprung the trap, and the nearly one thousand people in attendance watch in horror (we hope) as the body dropped to the ground. At first, it was thought that the rope had snapped, but Strong was too professional for that. Poor James Stone had been decapitated.[30]

Robert Strong also handled the most famous execution in the jail's history: that of Charles Guiteau, President Garfield's assassin. At his trial, Guiteau had horrified (and secretly delighted) America by shouting at the jury, "You are all low, consummate jackasses!" and telling the judge, "The doctors killed Garfield; I just shot him." He had a bit of a point on the last one. Strong dispatched him neatly, and this is when the press gave him the honorary title of "Colonel," which was a bit of a step down from his last one, "Lord High Executioner."

Hangings came fast and furious in those days, and stories began to circulate up and down the Anacostia River. The area was underdeveloped, and small pockets of people, largely African Americans, lived in shacks and

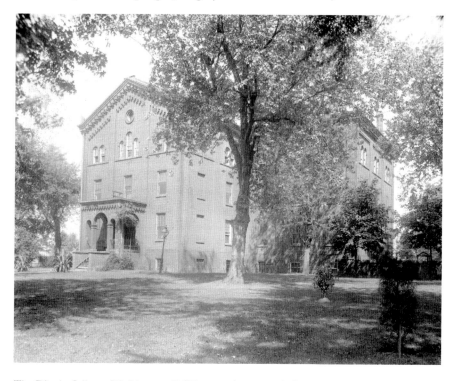

The District Jail was Washington, D.C.'s execution grounds from when it opened in the 1870s until the last one in 1957. *National Photo Company, Library of Congress, Prints and Photographs Division.*

even in small hamlets, particularly just to the north near Benning Road. Naturally, they were a bit uncomfortable with who they saw hanging about the jail after hours. A *Washington Post* article about Georgetown ghosts looked down on these ghosts as "cheap modern ghosts, which are vulgarly supposed to haunt the scenes of recent crimes." But it did mention that the jail held " a number of these specters, who have found their way out of the world through the trap of a certain platform in the northeast corridor [the gallows was in the northeast corner of the jail], and insist on coming back on stormy nights to make the dogs howl and raise goose flesh on the backs of the night watchmen."

The *Post* is dismissive and even condescending of these ghosts, writing them off as only suitable for "the Negro element" and insisting that they are "only what theosophical science now knows familiarly as the Jiva, or phosphorescent aggregation of ethereal molecules necessarily attendant on the violent taking off of a human being, and which will gradually fade and vanish as the soul principal has time to decently die and disintegrate." They are not to be confused with the "real 18-carat ghosts, dyed in the wool and a yard wide." Real ghosts lived in Georgetown and were white, at least in 1893.

Eventually, the jail replaced the hangman's noose with the electric chair, in keeping with the modern spirit of the times. In August 1942, Ole Sparky (or whatever they called it here) got quite the workout as six Nazi saboteurs were sent to the chair. They had landed on beaches in Florida and New York via U-boats with the mission of attacking targets around the country, including a hydroelectric plant in Niagara Falls, Hell Gate Bridge in New York and Penn Station, Newark. It was the first time a military court was used for someone other than a service member since the Lincoln assassination trials.

Also sent to the grave was Julius Fisher, a janitor who had bludgeoned to death Catherine Reardon, the librarian at the National Cathedral. Fisher had been hounded by Reardon, by all accounts a miserable lady, and one evening he finally snapped when Reardon called him a racial epithet. He smacked her, and terrified of what he had done, he bludgeoned her to death with a piece of firewood to keep her quiet. He then stashed her body in the subbasement of the Cathedral library. His guilt was never in doubt, but the clear lack of premeditation and extreme provocation meant that many people, including the *Washington Post* editorial board, felt that President Truman should commute his sentence. He did not, and Julius Fisher was electrocuted in 1946. Ten years later, in 1957, the jail executed its last person.[81]

A new jail, still in operation at Massachusetts Avenue and 19th Street SE, was built in 1976, and the old one was torn down shortly after. While the historic building is gone, elements of it live on. The stone was saved, red Seneca Creek sandstone from the same quarry as the Smithsonian Castle, and besides being used for repairs to the Castle itself, it was used to construct the Renwick Gate, an entrance on the south side of the Castle grounds that was designed by architect James Renwick but never built.

The grounds stood vacant and abandoned for decades. Brush grew up, and only a dilapidated chain-link fence feebly tried to keep visitors out. Did spirits still walk the grounds? Was James Stone looking for his lost head? Were Nazi saboteurs resigned to their fate? Did Julius Fisher have one last plea for justice? It certainly looked that way, and neighbors stayed clear, but even that spectral field is gone. In 2006, St. Coletta Special Education Public Charter School opened on the site and, to date, it has reported no ghosts. Today, children play where bodies once swung.

THE HEAD OF WILLIAM WIRT

Finally, while Hill East has only been home to a large number of the living for the last century or so, it's the permanent and final residence of more than fifty thousand Washingtonians. Historic Congressional Cemetery was founded in 1807 by Christ Church Episcopal Church, which is still thriving on G Street SE in the older part of the Hill. It's customary to refer to a cemetery as the final resting place of its inhabitants, but many of Congressional's residents are doing anything but resting.

William Wirt has been active both physically and supernaturally since his death in 1834. Wirt is seldom remembered today, but he was quite the influential figure in American politics in the early nineteenth century. He was attorney general from 1817 to 1829, to this day the longest tenure of any person, and was credited with turning it into a position of great influence. Late in his life, he argued on behalf of the Cherokee nation in front of the Supreme Court, winning the case of *Worcester v. Georgia*, which held that the federal government, not states, was responsible for relations with Indian tribes.

Some years after he passed away, the former governor of Tennessee and new postmaster general of the United States, Aaron V. Brown, moved into Wirt's house near Lafayette Square NW, just north of the White House.

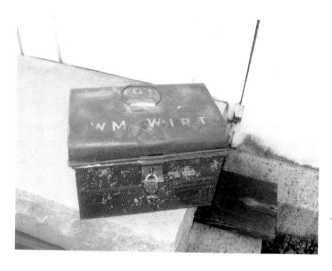

Just as it says, this box contained the skull of the Honorable William Wirt. *Photo by author.*

Brown was initially quite pleased to live in the house of such a famous attorney and bragged to his friends about its pedigree. Not only had Wirt lived in it, but during that time such luminaries as John C. Calhoun, Henry Clay, Daniel Webster and Andrew Jackson also were frequent visitors.

However, Brown's delight in such reflected glory was limited when it became apparent that death had not forestalled Wirt's legal debates. He continued to argue late into the evening with his nocturnal visitors, discussing the proper role of states' rights among other things. Brown was unable to sleep with the racket, and his performance at the Post Office Department suffered. He died in 1859, leaving the department's finances in shambles. Some blamed his fall from grace and eventual illness on the ghost of William Wirt, debating late into the evening with John Calhoun and the "eccentric and rhetorical Congressman John Randolph's shrill—almost soprano—voice."[82]

Wherever Wirt's spirit chose to roam, his corporal being wasn't confined to the grave either. In 2004, Congressional Cemetery received an unusual call from D.C. councilmember Jim Graham. A local bookseller had been asked to appraise a collection of curiosities from a recent estate and had come across a skull in a dusty box with "Hon Wm. Wirt" painted on it in red letters. Knowing that holding unexplained human body parts is generally considered a bad thing, he contacted his councilmember, who arranged for the safe return of the head of William Wirt to its proper place.

But when the cemetery entered the crypt under Wirt's massive, elaborate tomb, staff found the remains in disarray. The eight coffins had been opened, and the contents were scattered about. Douglas Owsley,

a noted forensic anthropologist from the Smithsonian, was brought in to bring order out of chaos. The remains were organized, and William Wirt's head was properly reunited with his body. To date, William Wirt, on all levels of existence, has not been reported elsewhere in Washington.[83]

BEAU HICKMAN: PRINCE OF AMERICAN BUMMERS

Another gentleman who has had difficulty staying in one place is Robert Singleton "Beau" Hickman. To call Beau Hickman a con artist is to call Leonardo da Vinci a painter—accurate, of course, but really in a select league of his own. An obituary put it well: "A man who lived by wit instead of work; who never paid a debt till he paid the debt of nature; who kept his books with world by that severely single entry system in which the entries are exclusively on one side."[84]

Much is reported about Hickman's origins, but little is verifiable. He was born in Maryland…or perhaps it was Virginia? Either way, it was to a wealthy family, and Hickman wanted no part of country gentility. He moved to Washington sometime in the 1830s…or perhaps it was in the 1840s? He came to town, by all reports, exuding wealth. Throughout his life, he would strongly discourage speculation about his origins, but it was well known that he had benefited from a large inheritance…or perhaps his family had simply paid him off to be rid of him?

He lived the life of a gentleman bon vivant among the fine hotels of Pennsylvania Avenue, but funds soon ran out, and he was left with his natty attire and an inexhaustible store of confidence. A favorite trick of his, reported up and down the eastern seaboard, would be to enter a fine dining establishment and stand purposefully until a waiter approached and asked if he would like to dine. Without a word, Hickman would nod and enjoy the finest the house could bring him. When presented with the check, he would adopt a pose of offended hauteur and demand to know of the proprietor why he was being charged when he had been invited to dine in the first place. Quite often the proprietor would ask if he would play the same trick on a competitor, only to find that the competitor had already paid Hickman to pull this scam on him that very night.

Beau was not his real name, and it's entirely possible that Hickman was not either. But he became a fixture about the Capital, and no visit to Washington would be complete without an introduction to Beau Hickman,

an introduction for which Hickman invariably, and charmingly by all accounts, charged a fee. When he died in 1873, Walt Whitman mentioned it in a letter to his friend (and presumed lover) Peter Doyle and noted that "half the papers in the land have had long obituaries and notices of the death of that rotten old apple, Beau Hickman."[85]

Beau's death hardly diminished his flame. A well-known Broadway press agent, Willard Holcomb, wrote a four-act play about the character, *A Gentleman Vagabond*, in 1897, and it was periodically produced in Washington and elsewhere until well after the turn of the century.[86] A book, *Life, Adventures, and Anecdotes of Beau Hickman: Prince of American Bummers*, was written by James Samuel Trout in 1879 and served to keep the legend alive as well. Up until 1910 or so, it was not uncommon to find references to Hickman; shortly after his death, a Tennessee newspaper referred to its senator as being as "useless as Beau Hickman."[87] He became a larger-than-life figure, almost a Paul Bunyon of confidence men and schmoozers. So well known was he that when his sister died twenty-seven years after him, her obituary ran in the front page of the *New York Times* as "Beau Hickman's Sister Dead."[88]

Upon his death, a group of gentlemen from the city of Washington collected funds for a proper burial. Hickman, naturally, had left no money

The final grave of Beau Hickman, or at least what remains of him, at Congressional Cemetery. *Photo by Otto Pohl.*

behind and had been buried in a pauper's grave. Feeling that this was no fitting end for such a notable character, they proceeded down to the potter's field by the Anacostia to retrieve Hickman. To their shock and horror, they discovered that Hickman's body had fallen prey to "resurrection men," who dug up fresh bodies and sold them to medical schools. His head, arms and legs had all been removed, but in their haste, the grave robbers had left the heart about fifteen feet away, wrapped in brown paper, near the knife used for the crime.

Naturally appalled at the scene, they bundled up what remained of Hickman and deposited him in the public vault at Congressional Cemetery. A little while later, a suitable spot was found, and Beau Hickman, or at least a sizable portion of him, was interred under a stone labeled simply "R.S. Hickman." He is, we assume, there today.

As you would expect of such an irrepressible character, Beau has been seen about town since his demise. Many reports have him strolling along his favorite haunts, the grand hotels of Pennsylvania Avenue. They're almost all gone now, but his favorite was the National Hotel, on the corner of 6th and Pennsylvania Avenue NW, torn down in 1892 to construct a building for the Atlantic Coast Railroad. Hickman was still seen walking its halls and stopping in on the never-ending card games until its destruction. Once the hotel was no more, "He sauntered forth with a hat well brushed, perfect fitting gloves and his usual boutonniere."[89]

Naturally, we should not be surprised that Beau Hickman would have no fixed address in death any more than he did in life. Hickman was also reported in a 1936 *Washington Post* article to have been making a great nuisance of himself at the Varnum Hotel, one of those grand old buildings about the Capitol that was torn down to build office buildings, in this case the Longworth House Office Building.[90]

GHOSTS OF THE CEMETERY PROPER

Like William Wirt and Beau Hickman, many of the ghosts of Congressional take up residence where they last lived or died rather than where their remains came to rest. David Harold, John Wilkes Booth's accomplice; Archibald Henderson, of Marine Barracks fame; Thomas Tingey, of the Navy Yard; and Robert Slight, the worker on the Capitol who fell to his death; are all interred here but haunt elsewhere. Robert Strong, our Lord

The grave of Captain Thomas Tingey. Captain Tingey is one of many residents of Congressional Cemetery who are seen elsewhere from time to time. *Photo by Otto Pohl.*

High Executioner, is buried here as well but seems to be untroubled in the afterlife. John Quincy Adams; Jonathan Cilley, the last congressman to be killed in a duel; John C. Calhoun; and Dolley Madison were interred here before being taken home. They also have reputable ghosts elsewhere. But what of the cemetery itself?

John Philip Sousa, legendary bandmaster of the Marine Corps Band, is said to linger about. On foggy evenings, people have reported hearing the lingering bass notes of the sousaphone, the tubalike instrument that Sousa had modified for marching bands. Supposedly, John Philip Sousa is still tweaking the design, as you'd expect from a master musician such as him.

Likewise, Matthew Brady has been reported wandering around the cemetery. Brady is well known for his Civil War photographs, and after the war, he expected the federal government to purchase his collection. When it failed to do so, he went bankrupt and was forced to sell his studio. Eventually, his wife passed away and his vision failed. He died penniless and alone in New York in 1896. He is reported to be seen walking among the many graves of congressmen in the cemetery, pleading his case to sell the glass-plate negatives of his photographs.

There is one ghost, or rather a spirit, that is felt at Congressional Cemetery in contemporary times. Cindy Hayes, the executive director of the Cemetery, has come across this spirit at least twice. The first time was an odd incident. The cemetery was having work done on the drains in the basement of the gatehouse. As anyone who has had such done in their house can sympathize, the contractors had begun construction and dug out the project but had not returned to complete it. Several months had gone by, and one afternoon, Ms. Hayes heard a tremendous crash while working in her second-floor office. No one else in the building heard it, and there was no sign of any disarray. About a week later, the cemetery manager went down to the basement and discovered that a wine rack had fallen over. Only two of the nearly five dozen bottles had broken.

Cindy felt that the spirit was telling her that the house and the cemetery were not in order and that she (Cindy is quite certain the spirit is female) was making a statement. Shortly after that, the contractors returned and work was finished.

In the other instance, the cemetery was preparing for a very large funeral, so large that the family had hired an event coordinator to put it on. Cindy

The walk from the Congressional Cemetery Chapel to the gatehouse. *Photo by author.*

met with him, and they discussed plans for a 150- by 60-foot tent with a raised platform and three rows of tiered seating. According to her account:

I was really very uncomfortable, about what the plan was, because this was not going to be a funeral—it was going to be a circus, including the circus tent. And I did not say, "No, you cannot do this," but I kept saying to him, "Are you really sure you want to have Seating A, Seating B, Seating C? And who's going to monitor all this?" And he said, "No, it will be fine; we'll do it in a very, very dignified way."

We walked out of the chapel; the day was as still as could be, not a bit of breeze. And as we turned the corner of the chapel, coming back toward the gatehouse, this huge wind appeared from nowhere and took all of the loose papers that were in his arms and threw them far into the air. We were both obviously very stunned because there was no wind. I helped him pick up his papers, and once we picked up his papers, we both stood there and looked at each other, and he said, "Maybe we need to rethink this."

The funeral was very dignified, and it was not a circus. And there were no tents installed outside the chapel. It was family only.

NOTES

Part I

1. Gordon Brown, *Incidental Architect: William Thornton and the Cultural Life of Early Washington, D.C., 1794–1828* (Athens: Ohio University Press, 2009), 6–8.

2. W. Thornton, C.M. Harris and D. Preston, *Papers of William Thornton* (Charlottesville: University Press of Virginia, 1995), 528.

3. Mary N. Woods, *From Craft to Profession: The Practice of Architecture in Nineteenth-century America* (Berkeley: University of California Press, 1999), 22–23.

4. John Alexander, *Ghosts, Washington Revisited: The Ghostlore of the Nation's Capital* (Atgen, PA: Schiffer Publishing Limited, 1998), 62.

5. John Alexander, *Ghosts: Washington's Most Famous Ghost Stories* (Arlington, VA: Washington Book Trading Company, 1988), 72.

6. George O. Gillingham, "A Demon Cat and Other Spooks Haunt the Halls of the U.S. Capitol," *Washington Post*, June 30, 1935, 9.

7. *Staunton Spectator and Vindicator*, "Many Ghosts in Capitol—Demon Cats that Jump Over Observer's Head," October 22, 1909, 1.

8. Joseph Lewis French, ed., *The Best Ghost Stories* (New York: Boni and Liveright, Inc., 1919), 191.

9. "Many Ghosts in Capitol," 1.

10. Theodore Parker, *A Discourse Occasioned by the Death of John Quincy Adams: Delivered at the Melodeon in Boston, March 5, 1848* (Boston, MA: B. Marsh, 1848), 26.

11. French, *Best Ghost Stories*, 194.

12. Interview with Steve Livengood, USCHS, by Tim Krepp, February 1, 2012.

13. David McCullough, *John Adams* (New York: Simon and Schuster, 2008), 576.

14. Patrick Cox, "Not Worth a Bucket of Warm Spit," *History News Network*, August 20, 2008, http://hnn.us/articles/53402.html.

15. *New York Times*, "Death of Henry Wilson" November 22, 1873.

16. French, *Best Ghost Stories*, 194.

17. Alexander, *Ghosts, Washington Revisited*, 69–70.

18. "Many Ghosts in Capitol," 1.

19. Gillingham, "Demon Cat and Other Spooks," 9.

20. Robert S. Pohl, *Wicked Capitol Hill: An Unruly History of Behaving Badly* (Charleston, SC: The History Press, 2012), 27–36.

21. *Burlington Weekly Free Press*, "Haunted Washington," October 30, 1919, 11.

22. *Afro-American*, "Senate Barber Refused 'Cal' and Turned Down Haiti," July 7, 1928.

23. Gillingham, "Demon Cat and Other Spooks," 9.

Part II

24. *Washington Post*, "A Phantom Wheelman," June 21, 1896.

25. Frank Moore, *The Civil War in Song and Story: 1860–1865* (New York: P.F. Collier, 1889), 30–31.

26. Eugene Warner, "Ghosts Roam Halls of Ancient Capital Homes as Hallowe'en Nears," *Washington Post*, October 25, 1936, Section B, 5.

27. Alexander, *Ghosts, Washington Revisited*, 55–56.

28. Robert V. Remini, *The House: The History of the House of Representatives* (New York: HarperCollins Publishers, 2006), 259–61.

29. French, *Best Ghost Stories*, 193.

30. Gillingham, "Demon Cat and Other Spooks," 9.

31. Benjamin G. Cloyd, *Haunted by Atrocity: Civil War Prisons in American Memory* (Baton Rouge: Louisiana State University Press, 2010), 33–34.

32. *Washington Post*, "A Kentuckian's Steadfastness: An Incident in the Life of the Late Judge Holt, of This City," August 8, 1894, 4.

33. *Washington Post*, "Historic Buildings Gone: Old Homes Once Where Congressional Offices Will Stand," April 3, 1904, 6.

Part III

34. *Washington Post*, "Washington Ramble: The History of Duddington Manor and Its Owner, Daniel Carroll," September 2, 1883, 1.
35. *Washington Post*, "Old Georgetown Ghosts—That Is the Stamping Ground for District Specters," July 16, 1893.
36. Tarot Teachings, "Symbol Meanings of the Tarot," http://www.tarotteachings.com/symbol-meanings-of-tarot-l-r.html.
37. Ruth Ann Overbeck and Nancy Metzger, "Capitol Hill: The Capitol Is Just Up the Street," in *Washington at Home*, ed. Kathryn Schneider Smith (Baltimore, MD: Johns Hopkins University Press), 39.
38. Robert Pohl, "Another Great Theory Slain by an Inconvenient Fact," The Hill Is Home, September 6, 2010, http://www.thehillishome.com/2010/09/another-great-theory-slain-by-an-inconvenient-fact.
39. Edward T. James and Janet Wilson James, *Notable American Women: A Biographical Dictionary* (Cambridge, MA: Harvard University Press, 1974), 242.
40. *Washington Times*, "Mrs. Briggs' Generosity—Wants to Present the City With a Square of Ground," April 2, 1896, Evening Edition, 2.
41. *Washington Times*, "Passing of a Landmark," April 29, 1900.
42. *Washington Herald*, "All Honor Swastika—Poetic Muse Riegns Supreme at The Maples," July 7, 1907, 8.
43. Alexander, *Ghosts, Washington Revisited*, 83–84.
44. Madison Davis, "The Navy Yard Section During the Life of the Rec. William Ryland," *Records of the Columbia Historical Society, Washington, D.C.*, vol. 4 (Washington, D.C.: Columbia Historical Society, 1901), 217.
45. *Vermont Phoenix*, "Deplorable Suicide," September 25, 1845.
46. *Washington Times*, "Collier Is Bound Over to Grand Jury Today—Murder Is Charge Against Policeman Who Slew Captain," March 6, 1909, 1–2.
47. *Washington Times*, "Motive Advanced for Collier's Act," March 7, 1909, 1–2.
48. *Washington Post*, "Collier Is Silent—Slayer of Capt. Mathew Is Held for Grand Jury," March 7, 1909, 1.
49. *Washington Post*, "Collier Tells Story—States that He Shot Mathews in Self-Defense," December 4, 1909, 16.
50. *Washington Star*, "Washington's Haunted House—The Ghost of a Wicked Marine," October 14, 1871.
51. Alexander, *Ghosts, Washington Revisited*, 98–99.

Part IV

52. *New York Times*, "The Washington Navy Yard," November 10, 1895.
53. Michael Moore, "Its First Gunboat a Failure," *Washington Post and Times Herald*, March 19, 1958, Section A, 16.
54. Albon B. Hailey, "Will Famous Ghost Return to the Navy Yard?" *Washington Post*, December 3, 1961, Section B, 1.
55. Moore, "Its First Gunboat a Failure."
56. Charles Ball, *Slavery in the United States: A Narrative of the Life and Adventures of Charles Ball, a Black Man, Who Lived Forty Years in Maryland, South Carolina and Georgia, as a Slave Under Various Masters, and Was One Year in the Navy with Commodore Barney, During the Late War* (New York: John S. Taylor, 1837), 468.
57. Abner Riviere Hetzel, ed., *Military Laws of the United States: Including Those Relating to the Army, Marine Corps, Volunteers, Militia, and to Bounty Lands and Pensions* (Washington, D.C.: G. Templeman, 1846), 251.
58. Gorman M. Hendricks, "Haunted Houses and 'Undead' Found Here: Citizens of Nearby Hamlet Declare Beautiful Girl, Slain by 'Vampire,'" *Washington Post*, September 30, 1923, 75.
59. Major Robert E. Mattingly, "One of a Kind, Unique…," second chapter of *Herringbone Cloak—GI Dagger: Marines of the OSS* (Quantico, VA: Marine Corps Command and Staff College, 1979), 31.
60. Mary V. Stremlow, *Free a Marine to Fight: Women Marines in World War II* (Washington, D.C.: DIANE Publishing, 1996), 1–2.

Part V

61. Gaeta Wold Boyer, "Old Washington Houses Harbor Many a Friendly Ghost of By-Gone Days: Legends Somber and Gay Cluster About Historic Mansions Here," *Washington Post*, April 28, 1935, Section FS3.
62. Alfred H. Terry, "Spiritualism," Letters to the Editor, *Washington Post*, March 22, 1940, 14.
63. Denis P.S. Conan Doyle, "Mr. Conan Doyle Clarifies His Position," *Washington Post*, March 31, 1940, Section B9.
64. Boyer, "Old Washington Houses."
65. *Washington Post*, "Police After a Ghost: Strange What-Is-It Seen by the Citizens of the Northeast," November 26, 1895.
66. Ibid.
67. Ibid.

68. Interview with Adele Robey by Tim Krepp, March 4, 2012.

69. *Washington Post*, "Dying Boy's Long Trip: Sent from Hospital to Hospital in Patrol Wagon," October 16, 1905, 2.

70. *Washington Post*, "Doctor Made Error: Rules at Casualty Do Not Bar Children Patients," October 21, 1905, 2.

71. John Quincy Adams, *Memoirs of John Quincy Adams: Comprising Portions of His Diary from 1795 to 1848*, vol. 10, ed. Charles Francis Adams (Philadelphia, PA: J.B. Lippincott & Company, 1876), 366.

72. *Washington Post*, "Grave Robbers Escape—Clew to Men Who Entered Patterson Vault Sought in Vain," September 26, 1915, 8.

73. *Washington Post*, "Robbers Plunder Dead—Desecrate Remains in Coffins in Old Family Burial Vault," September 21, 1915, 1.

74. *Washington Times*, "Vault Desecrated, Bodies Are Removed— Representatives of Old Patterson Estate Reinter Remains in Old Sepulchre," October 1, 1915, 6.

75. Gorman M. Hendricks, "Haunted Houses and 'Undead' Found Here: Citizens of Nearby Hamlet Declare Beautiful Girl, Slain by 'Vampire,'" *Washington Post*, September 30, 1923.

76. Rachel Burton and Kristen Suiter, "The Presidential Ghost," *World Around You*, March/April 2001, 4–5.

77. *On the Green*, "Halloween Brings Out Stories of Skeletons in Closets," October 30, 1989.

Part VI

78. *Washington Times*, "Barrett Held as Important Witness in Brewery Crime," October 3, 1912, 1.

79. *Washington Times*, "Hangman Strong Dead—He Was the Jolliest Jack Ketch in the Whole County," June 30, 1895, 1.

80. *Daily Globe*, "Hanging Horrors—Terrible Scene at an Execution in Washington," April 3, 1880, 1.

81. *Washington Post*, "Case for Commutation," June 22, 1946, 6.

82. Alexander, *Ghosts, Washington Revisited*, 40–41.

83. Peter Carlson, "Tale From the Crypt," *Washington Post*, October 20, 2005.

84. *Weekly Kansas Chief*, "Story of an Old Beau," April 10, 1879, 1.

85. Fernando Alegría, *Calamus: A Series of Letters Written During the Years 1868– 1880* (Boston, MA: L. Maynard, 1897), 114.

86. *Times*, "Theatrical Gossip," August 1, 1897, Morning Edition.

87. *Knoxville Weekly Chronicle*, "The Blunderers," June 18, 1873, 4.

88. *New York Times*, "Beau Hickman's Sister Dead—Was the Last Survivor of the Family Made Famous by Her Brother," April 14, 1990.
89. *Arizona Weekly Journal-Miner*, "Beau Hickman's Mistake," March 23, 1892.
90. Warner, "Ghosts Roam Halls," 5.